# French Art
## from the
## Davies Bequest

National Museum of Wales
Cardiff 1982

# French Art
## from the
## Davies Bequest

by Peter Hughes

First published in June, 1982
© National Museum of Wales
ISBN 0 7200 0235 4 (soft cover)
ISBN 0 7200 0255 9 (hard cover)

Production: Hywel Gealy Rees
Design: Penknife, Cardiff
Typesetting: Filmset by Garland Graphics Ltd., Bristol
Photography: Eric Broadbent
Colour separations: TPS (Technigraphics) Ltd., Cardiff
Paper: Ikonolux Art supplied by the Robert Horne Paper Co.
Printing: South Western Printers Ltd., Caerphilly

This book is also published in Welsh, French and German

# Contents

# Foreword

The first exhibition of pictures under the auspices of the National Museum of Wales was arranged in a temporary museum at the City Hall, Cardiff between 4 February and 28 March 1913. The event was made possible by a 'few friends interested in art, who desire to remain anonymous'. These friends lent their treasures and defrayed the expenses of the exhibition and the lectures connected with it 'in the hope that the Welsh people will derive pleasure and profit from them'.

The exhibition fulfilled the hopes of the donors and was described as one of the greatest artistic events in the history of Wales. In it the visitor had a brief glimpse of the glory that was later granted to the National Museum in the bequests of two of the anonymous 'friends' – the Misses Davies of Gregynog, Montgomeryshire.

The sisters Gwendoline and Margaret had built up their collection jointly between 1908 and 1924, by which date it was essentially complete. Although it contained works of other schools and other periods, it was primarily for its 19th century French paintings and sculpture that it was, and remains, famous. By 1924 it was the largest collection of French impressionist and post-impressionist paintings in Britain (containing a number of earlier 19th century French works as well) and exerted a considerable influence on subsequent British collectors of French painting, notably Samuel Courtauld.

It was the accession of these French works in the two bequests – of Gwendoline Elizabeth Davies in 1952 and Margaret Sidney Davies in 1963 – that enhanced the standing of the Museum collection almost beyond recognition.

The story of the formation of the Davies collection has been told by John Ingamells in *The Davies Collection of French Art,* published by the Museum in 1967. In it he describes the majority of the French works and his book remains one of the major public salutes to the two benefactors. The collection as a whole has, however, yet to be described and, furthermore, it has never been

possible to see it in its entirety in one place. In the twenties, for example, some of the purchases, including the large bronzes by Rodin came straight to the National Museum. *The Kiss* has graced the Main Hall ever since the building was opened to the public. And now a small section of the collection remains in Gregynog Hall and another is at the National Library of Wales at Aberystwyth.

Many thousands of people every year have continued to derive pleasure and profit from the paintings in the galleries of the Museum and the two sisters, who were extremely generous patrons of many arts and organisers of festivals of poetry and music at Gregynog, would have appreciated the interest shown by both Welsh and Anglo-Welsh poets. John Ormond, for example, who asks a rhetorical question of M. Renoir:

*Did you then celebrate*
*That grave discovered blue*
*With salt thrown on a fire*
*In honour of all blues?*

*I mean the dress of La Parisienne*
*(Humanly on the verge of the ceramic),*
*Blue of Delft, dream summary of blues,*
*Centre-piece of a fateful exhibition;*

*Whose dress-maker and, for that matter,*
*Stays-maker the critics scorned;*
*Who every day receives her visitors*
*In my country where the hard slate is blue …*

And Bryan Martin Davies who, in response to the single painting by Van Gogh, *Rain at Auvers*, draws attention to one feature in common between Wales and Auvers:

*Fel gŵr cynefin â glaw*
*daliaist mewn llinellau*
*y gwewyr gwlyb*
*a syrthiai*
*dros y caeau ŷd*
*yn Auvers …*

*A ninnau,*
*yma,*
*rydyn ninau'n*
*gynefin â glaw.*

The sisters would also have welcomed the Museum's practice of holding recitals of music and poetry in the galleries where the Davies pictures hang.

In spite of the many visitors, however, the collection is not as widely known as it deserves to be. When a selection of the paintings was exhibited in Paris in 1980, the Curator of the Musée Marmottan prefaced the catalogue with the following words:

*Les chefs-d'oeuvre impressionnistes français du Musée national du Pays de Galles, sont pratiquement inconnus en France. Et pourtant, ces tableaux acquis par les soeurs Davies, de Cardiff, entre les années 1909 et 1960 constituent une collection d'exceptionnelle qualité.*

And he also had this to say in describing the exhibition in the French art journal *L'Oeil*:

*Une collection est une suite d'actes d'amour, d'enthousiasmes, et aussi une preuve de persévérance. En cela, le collectionneur est toujours respectable et on ne peut que le louer, lorsque son goût a la qualité de celui des soeurs Davies.*

The exhibition obviously helped in bringing the paintings to the attention of additional viewers. The present book is an attempt to bring it to the attention of many more. It presents illustrations of all the French pictures and sculpture in the Museum's collection in a convenient format with a generous number in full colour. Because of the international importance of the collection the book has also been published in Welsh, French and German. Its publication appropriately celebrates both the centenary of the birth of Gwendoline Davies and the 75th Anniversary of the National Museum of Wales, and has been made possible by further patronage from Gregynog.

**Douglas A. Bassett,** Director

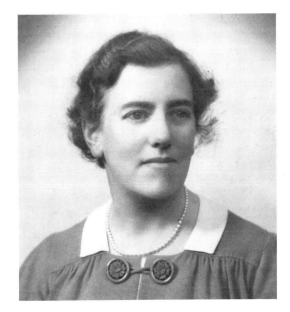

**1 Gwendoline Davies in 1937**

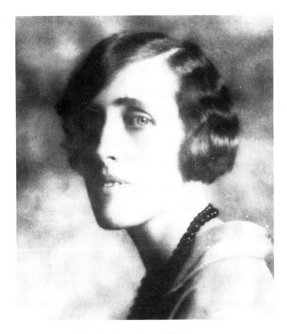

**2 Margaret Davies in about 1930**

3

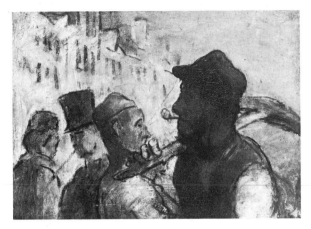

### 3 Workmen in the Street
1838–40, oil on panel, 4½ x 6½ ins., 11.4 x 16.5 cm

Daumier made his living as a caricaturist, or, as we should say nowadays, as a cartoonist. Between 1830 and 1870 he produced about 4,000 lithographs for satirical papers such as *La Caricature* and *Le Charivari*. It is, perhaps, not surprising that many of his paintings appear to be drawn rather than painted; the heavy black lines defining the figures are like those made by a lithographic crayon. In fact this tiny picture is more like a coloured drawing than a painting.

Gwendoline Davies purchased *Workmen in the Street* from Wallis and Son, Pall Mall, in November 1913.

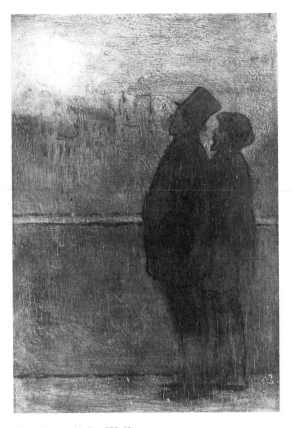

### 4 The Moonlight Walk
1838–40, oil on panel, 11 x 7½ ins., 27.9 x 19 cm

The heavy black line round the figures is still more noticeable than in *Workmen in the Street*, being more continuous than there. Once again, the scene is in Paris, and it appears to be set on a bridge crossing the Seine. Daumier was a contemporary of the Barbizon painters, of Corot and of Millet, but unlike them his art is urban, indeed specifically Parisian. Here the outline of one of the *quais* is only sketched in, but it sets the painting firmly in the city, while the moonlight adds a romantic quality to the scene.

Gwendoline Davies bought *The Moonlight Walk* from Wallis and Son, Pall Mall, in December 1912.

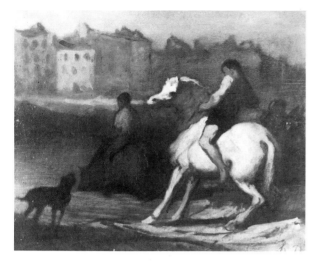

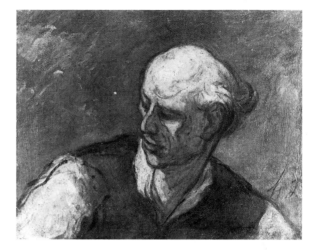

**5  The Watering Place**
About 1855, oil on panel, 17½ x 22 ins.,
44.3 x 55.1 cm

In 1846 Daumier moved to an apartment on the Quai
d'Anjou which is on the north side of the Ile Saint
Louis, the smaller island upstream from the Ile de la
Cité. From his window Daumier would have been
able to see horses being watered in the branch of the
Seine which flows round the north side of the island.
By letting the evening light fall on the slightly rearing
horse Daumier has given an epic quality to the scene.
The technique is different from that in the two early
paintings; the heavy black outline has gone and the
forms are painted, rather than drawn.

Margaret Davies bought *The Watering Place* from
Colnaghi's, Bond Street, in July 1914.

**6  Head of a Man**
About 1855, oil on canvas, 10¼ x 13½ ins.,
26.4 x 34.4 cm

This is considered to be a finished study after the
central head in a painting called *The Family on the
Barricades* in the Narodni Gallery in Prague. That
painting shows a half-length view of a man with his
wife to the left and their two small boys below them;
it reflects the Revolution of 1848 when the uprisings
in Paris led to the downfall of the monarchy of Louis
Philippe and the establishment of the Second
Republic. Unfortunately, the painting in Prague has
been reworked by another hand, although its
composition is due to Daumier. This study is,
however, by Daumier himself and for a passionate
Republican like him the image must have been a
precious one, particularly as this study was probably
painted when the short lived Second Republic had
been replaced by the Second Empire of Louis
Napoleon. A drawing in the Davies collection
(see No. 11) is thought to represent the starting point
for this head.

Gwendoline Davies bought *Head of a Man* from
Wallis and Son, Pall Mall, in February 1914.

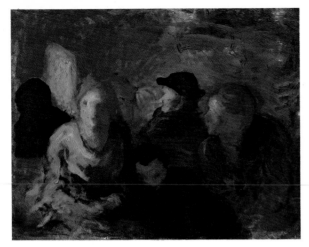

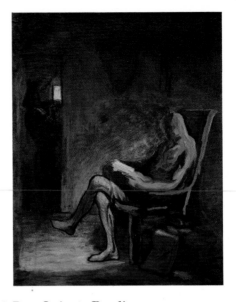

**7 Third Class Railway Carriage**
About 1865, oil on panel, 10 x 13 ins., 25.4 x 33 cm

The railway carriage theme occupied Daumier's mind recurrently in the years 1860–5 and appears in oils, watercolours and drawings. First and Second Class carriages occur among the drawings, but only the Third Class theme is found in his oil paintings. The present example is a sketch, so the facial expressions of the passengers are not worked out. The colour is unusually rich for Daumier, particularly the turquoise on the woman in the foreground. As in the other Third Class scenes we are looking at several rows of passengers at once, making for quite a complex composition.

The Misses Davies bought two *Third Class Railway Carriage* paintings in 1919; both had been in the Drummond sale at Christie's in that year. Margaret Davies sold the more finished of the two in 1960.

**8 Don Quixote Reading**
1865–7, oil on canvas, 32 x 25 ins., 81.3 x 63.5 cm

This is an unfinished sketch, only the legs of the seated Don Quixote being completed. In the final version, which is in the National Gallery of Victoria, Melbourne, the gaunt face of the seated Don is worked out in some detail; the picture is less than half the size of the present sketch. Cervantes's novel was Daumier's favourite reading and he painted about twenty subjects from it. This one evokes a main theme of the novel since it was from his reading of the romances of chivalry that Don Quixote derived his eccentric ideas. The two figures in the doorway are the village priest and the housekeeper who plot, in the early part of the novel, to burn some of the Don's books and to have the door into his library walled up so that he can no longer enter it. This sketch once belonged to Degas, but appeared in his sale without its present title, which was restored to it by K. E. Maison in 1952.

Gwendoline Davies bought *Don Quixote Reading* from the Bernheim-Jeune Gallery in Paris in March 1918.

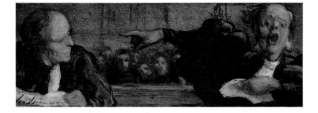

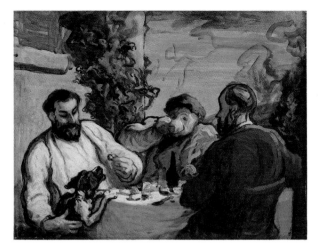

**9 Lunch in the Country**

1868, oil on panel, 10 x 13 ins., 25.4 x 33 cm

Daumier has reverted here to having a black outline round the figures, but it is handled with a new fluency and the paint is much richer than in an early work such as *Workmen in the Street*. As in Dutch 17th-century genre painting Daumier has stressed the healthy animality of the scene; one of the replete diners offers a scrap to a dog which looks emaciated in contrast, and the cup from which the furthest figure is drinking becomes almost part of his face in the form of a snout.

   Gwendoline Davies bought *Lunch in the Country* from the Bernheim-Jeune Gallery in Paris in April 1917.

**10 A Famous Case**

Oil on panel, 5 x 14 ins., 12.7 x 35.6 cm

With his move to the Quai d'Anjou in 1846 Daumier was only a short distance upstream from the Ile de la Cité where the principal French law courts are situated in the Palais de Justice. His prodigious visual memory must soon have built up a vast store of characteristic legal situations and types. K. E. Maison reserves judgement in his catalogue of Daumier's works on whether this painting is by Daumier or not. The painting repeats the two lawyers who appear in a watercolour with the same title in a private collection in Paris; the watercolour was accepted by Maison as a genuine work by Daumier.

   Gwendoline Davies bought *A Famous Case* from the Bernheim-Jeune Gallery in Paris in March 1920.

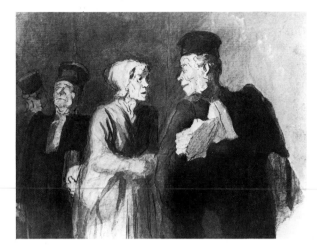

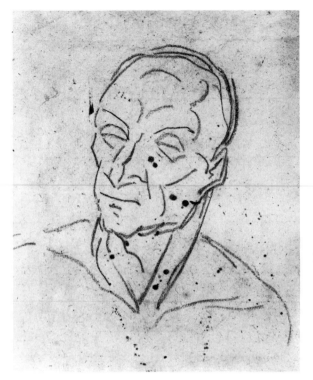

## 11 Head of a Man
Black chalk, 7 x 5¾ ins., 17.8 x 14.6 cm

This drawing is considered to be the starting point for the central figure in *The Family on the Barricades* in Prague and for the oil study *Head of a Man* in the Davies collection (see No. 6). If one were to be presented with this drawing out of context one might almost think it was an early 20th century work influenced by Cubism. Behind the economy of Daumier's style there is a profound sense of volume and of structure.

This drawing was bought by Gwendoline Davies in December 1922 from an exhibition of works by Daumier held at the Lefevre Gallery, London.

## 12 A Lawyer and his Client
Pen, black chalk and watercolour, 6½ x 8½ ins., 16.5 x 21.6 cm

This is really a monochrome drawing, despite touches of body colour on the faces and of blue on the woman's clothing. Daumier has brought the resources of a caricaturist to bear on a scene he must often have witnessed in the Palais de Justice – a worried client asking her insouciant lawyer how her case is going. The caricaturist's technique is best seen in the second head from the left: no more than a few pen strokes were needed for this masterly portrayal of self-satisfaction.

Gwendoline Davies bought *A Lawyer and his Client* from the Galerie Barbazanges in Paris in the spring of 1921.

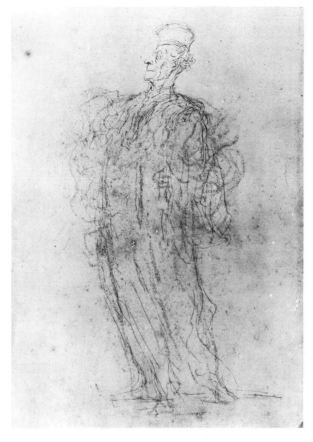

**13 A Lawyer Walking**
Pen and black chalk, 15 x 9¾ ins., 38.1 x 24.8 cm

This drawing was also known in the past as *The Public Prosecutor* and certainly the lawyer depicted looks self-important enough for such an office! The gown is a swirl of black chalk, but for the head and face Daumier has used, in contrast, the precise medium of pen and ink.

   This drawing was one of four bought by the Misses Davies in December 1922 from an exhibition of works by Daumier held at the Lefevre Gallery, London.

**14 The Return of the Prodigal Son**
Pen and wash, 8 x 4¾ ins., 20.3 x 12.1 cm

These two studies were formerly known as *The Good Samaritan* and *The Blind Man and the Cripple* respectively. K. E. Maison, in his catalogue of Daumier's works, identified both of them as studies for the theme of the Prodigal Son.

   The sheet with these two drawings on it was bought by Gwendoline Davies in December 1922 from an exhibition of works by Daumier held at the Lefevre Gallery, London.

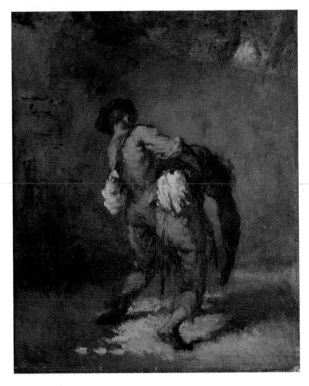

## 15 The Good Samaritan
1846, oil on canvas, 15½ x 12½ ins., 39.4 x 30.5 cm

Millet was born near Cherbourg in Normandy, moving to Paris, where he spent most of the years 1837–1849, and then settling in the village of Barbizon in the Forest of Fontainebleau, where he spent the rest of his life. This painting is a work of his Parisian period and is a literary, biblical subject in keeping with current Salon taste. Nevertheless, the fact that the figures are depicted walking into the landscape, so that their faces are not seen, makes the painting less anecdotal than most mid-19th-century subject pictures.

Gwendoline Davies bought *The Good Samaritan* from Wallis and Son, Pall Mall, in July 1910.

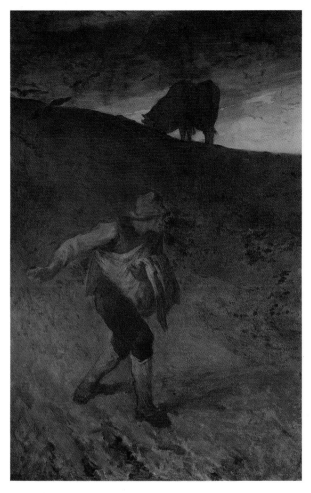

### 16 The Sower

1847–8, oil on canvas, 37 x 23½ ins., 94 x 59.7 cm

The Davies collection *Sower* is a preliminary version of the *Sower* which Millet exhibited at the Salon of 1850–1 and which made him famous. In the latter picture, now in the collection of the Provident National Bank, Philadelphia, the pose of the sower is given much greater vigour by lengthening his stride and increasing the twist of his body; greater drama is added by moving the figure onto the skyline. The Davies painting, on the other hand, emphasises the steepness of the hill, showing that the scene is set, not in the area of Barbizon, but among the coastal slopes of the Cherbourg peninsula, Millet's native country.

Gwendoline Davies bought *The Sower* from Wallis and Son, Pall Mall, in June 1911.

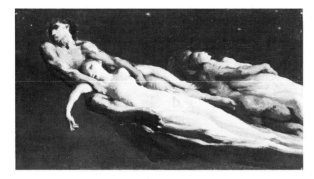

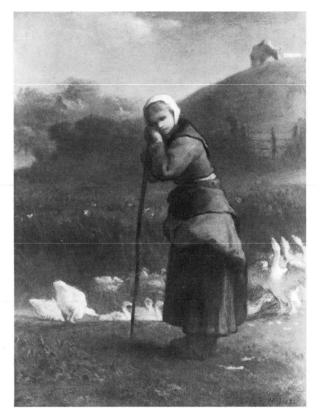

**17 The Shooting Stars**
1848–9, oil on panel, 7 x 13 ins., 17.8 x 33 cm

This small painting is thought to be an illustration of
the fifth Canto of Dante's *Inferno*, which describes the
souls of the lustful 'across the sky in long procession
trailing'. It must, therefore, portray Francesca da
Rimini and her lover, Paolo. Francesca was married to
Giovanni Malatesta, over-lord of Rimini in the early
13th century, but succumbed to an illicit passion for
her brother-in-law, Paolo, which is the subject of one of
the tenderest passages in the *Inferno*. The painting is
thus very much a literary subject from Millet's
Parisian period.

Gwendoline Davies bought *The Shooting Stars*
from Wallis and Son, Pall Mall, in December 1912.

**18 The Little Goose Girl**
1854–6, oil on canvas, 12 x 9 ins., 30.5 x 22.9 cm

This painting dates from after Millet's move to the
village of Barbizon, but, like *The Sower*, it is a
reminiscence of Normandy. Indeed, Millet and his
family spent the whole summer of 1854 at his native
hamlet of Gruchy, so this picture was probably begun
then. We are looking up-hill from the direction of the
sea; the little valley in the middle ground is formed
by a stream in which the geese are watering and the
houses at the top are the end of the hamlet of
Gruchy.

Gwendoline Davies bought *The Little Goose Girl*
from Hugh Blaker, principal picture adviser to the two
sisters, in May 1909.

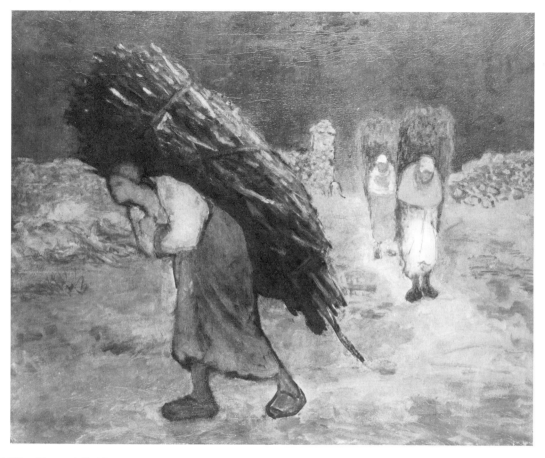

**19 The Faggot Gatherers**
1868–75, oil on canvas, 31 x 38½ ins., 78.7 x 97.8 cm

This painting was left unfinished at the time of Millet's death but the theme had been in his mind for at least twenty years. A most impressive drawing from the early 1860s, now in Boston, shows very much the same figures advancing against a background of trees drawn as vertical pencil strokes. Earlier still, a letter Millet wrote in 1851 refers to the subject thus: 'One sees a poor, heavily laden creature with a bundle of faggots advancing from a narrow path in the fields. The manner in which this figure suddenly comes before one is a momentary reminder of the fundamental condition of human life, toil'.

*The Faggot Gatherers* was originally intended to represent *Winter* as one of a set of four Seasons commissioned by the Alsatian industrialist, Frédéric Hartmann, in 1868. The four paintings were reunited at the Millet exhibition held in Paris and London in 1975–6.

Gwendoline Davies bought *The Faggot Gatherers* from Wallis and Son, Pall Mall, in December 1912.

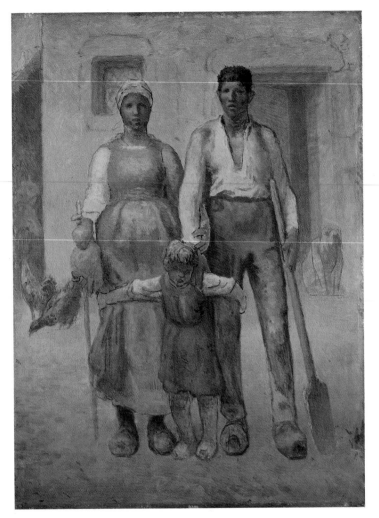

**20 The Peasant Family**
1871–2, oil on canvas, 43½ x 31¾ ins., 111 x 80.5 cm

Like *The Faggot Gatherers* this painting was left unfinished at the time of Millet's death and like the former painting it was a subject he had thought about for a considerable time. The French peasant was, for Millet, a traditional and moral survivor in an age of increasing corruption. It is, perhaps, not surprising that this group should convey something of the feeling of a Holy Family. This feeling is heightened by the immense simplicity and solidity of the figures which are reminiscent of early Italian paintings, particularly those of Piero della Francesca who often uses this direct frontal view of the human figure.

Margaret Davies bought *The Peasant Family* from Arnold and Tripp in September 1911.

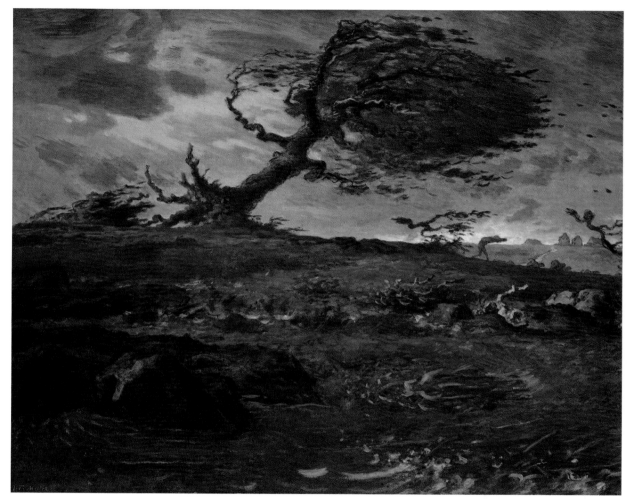

**21 The Storm**
1871–3, oil on canvas, 35½ x 46 ins., 90 x 117 cm

Professor Herbert has identified the setting of this landscape as the high plateau which runs through the centre of the peninsula of La Hague which juts out into the English Channel west of Cherbourg. No doubt Millet had witnessed storms in such a windswept spot, but there is also a strong element of romanticism in the painting, not least in the way the tiny figure of the shepherd rushing after his fleeing flock is contrasted with the huge bulk of the uprooted tree, emphasising the power and majesty of Nature.

Margaret Davies acquired *The Storm* from Hugh Blaker, principal picture adviser to the two sisters, in 1937.

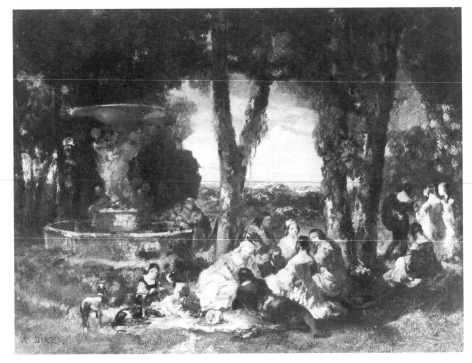

**22 Fête Champêtre**

Oil on canvas, 9½ x 12¾ ins., 24 x 32.4 cm

Despite his Spanish-sounding surname Diaz de la Peña was of French nationality and had been born in Bordeaux. A self-taught painter, he became closely associated with the Barbizon school of painters, notably with Millet and with the landscape painter Théodore Rousseau. But although his manner of painting, with its freedom of handling and rich colour, is in keeping with theirs, his subjects are often traditional. This picture looks back to Watteau and the French 18th century in its choice of a *fête galante* as subject and it is reminiscent, too, of Watteau in the inclusion of a stone sculptured fountain which contrasts with the liveliness of the human figures.

*Fête Champêtre* was purchased by Hugh Blaker for Margaret Davies at the Alexander Young sale at Christie's in 1910.

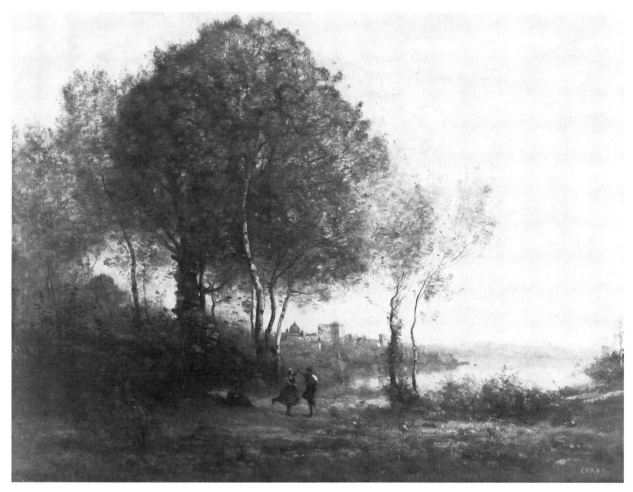

**23 Castel Gandolfo**

1855–60, oil on canvas, 19 x 25½ ins., 48.3 x 64.8 cm

Castel Gandolfo is the summer residence of the Pope, situated by Lake Albano in the Roman campagna, the countryside which had been the inspiration for Claude Lorraine in the 17th century; of the French 19th century painters represented in the Davies collection Corot is, in many ways, the most traditional. The original title of this painting was *Castel Gandolfo, with Tyrolian Shepherds dancing by Lake Albano*, but the idyllic, pastoral mood is more important than the topography. Attention is focused on the dancing shepherd couple by giving the man a brilliant red cap and the woman a yellow headscarf and the couple are as important in setting the mood of the painting as are the dancing figures in Claude's *Marriage of Isaac and Rebecca* in the National Gallery, London.

Gwendoline Davies bought *Castel Gandolfo* from the Obach Gallery, London, in October 1909.

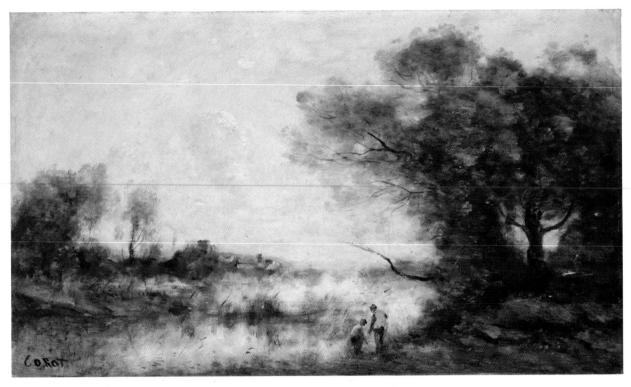

## 24 The Pond

1860–70, oil on canvas, 15½ x 26¾ ins., 39.4 x 67.9 cm

The Corot paintings in the Davies collection are all late works; this one, for example, was painted when the artist was at least in his mid-sixties. The silvery-grey tones and poetic atmosphere of paintings like this one proved much more popular with the Salon public than the solid, factual views of Italy he had painted when young. In buying landscapes by Corot Gwendoline and Margaret Davies were not departing from the general run of Edwardian taste, as they did in so many of their other purchases.

*The Pond* was bought for Gwendoline Davies at the Stephen Holland sale at Christie's in June 1908.

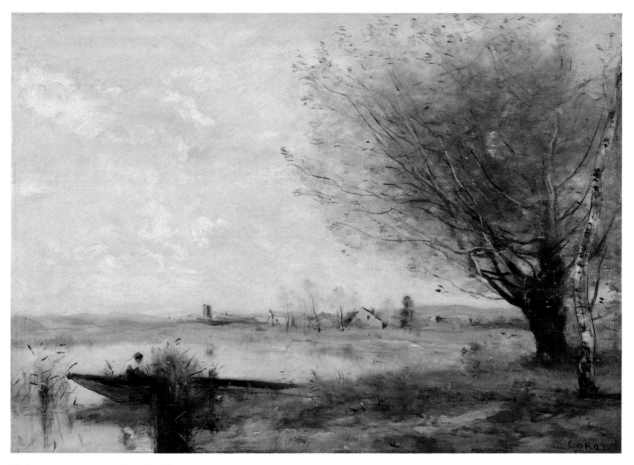

**25 Fisherman moored to the Bank**
1865–70, oil on canvas, 13⅛ x 18¼, 33.3 x 46.3 cm

As in *Castel Gandolfo*, a red cap is used to draw attention to the figure in this landscape. But the touch of bright colour is also intended to emphasise the subtlety of Corot's tones, the grey-blues, greens and buffs. Fishermen in boats occur in a number of Corot's paintings of the 1860s, including ones with Italian subjects, like the *Lake of Terni* in the Corcoran Gallery, Washington D.C.

Margaret Davies bought *Fisherman moored to the Bank*, from the Stephen Holland sale at Christie's, in June 1908.

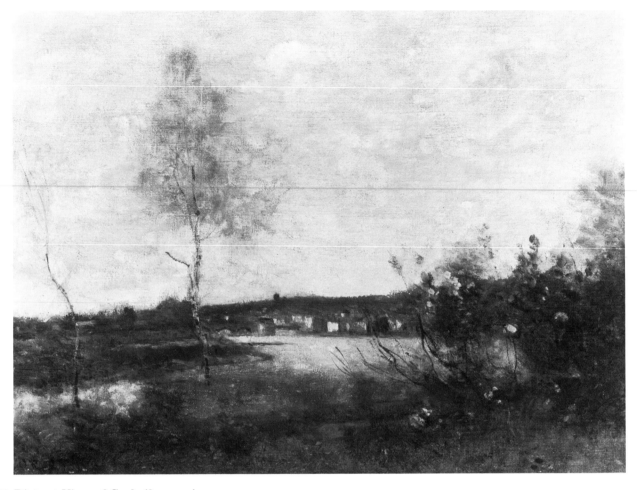

**26 Distant View of Corbeil, morning**

About 1870, oil on canvas, 9¾ x 13¼ ins., 24.8 x 33.6 cm

This painting was known until 1948 as *Joinville sur Marne*. In fact it shows a town much nearer Paris and on a different river, the Seine, not the Marne. Corbeil is south of Paris, about half way to Fontainebleau and Barbizon. The purple blossom in the right foreground fulfils much the same purpose as the red cap in *Castel Gandolfo* and *Fisherman moored to the Bank*, emphasising the subtlety of the other colours, which are here specified, as in Impressionist landscapes, as those of a particular time of day. The picture is very thinly painted, the foliage of the birch tree being rendered with great subtlety simply by allowing the canvas ground to appear through the paint of the sky.

Margaret Davies bought *Distant View of Corbeil* (*Joinville sur Marne*) from the Alexander Young sale at Christie's in June 1910.

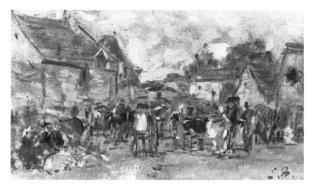

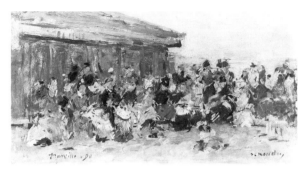

**27 Village Fair**
Oil on paper on panel, 4½ x 7¾ ins., 11.4 x 19.7 cm

Boudin was born in Honfleur and spent most of his life painting on the Channel coast, so this is presumably a Normandy village near the sea or a short distance inland. The sketch is painted on buff coloured paper which shows through in many places, including the sky, which is just touched in with patches of white and pale blue.

Margaret Davies bought *Village Fair* from the Lefevre Gallery, London, in April 1924.

**28 Beach at Trouville**
1890, oil on panel, 5½ x 10¾ ins., 14 x 27.3 cm

Trouville, a short distance south of Le Havre and the mouth of the Seine, was a fashionable resort in the late 19th century, frequented during the Second Empire by the Empress Eugénie herself. The figures in this sketch are clearly a fashionable company; there are patches of bright colour, red, blue and yellow, among their clothes, including a brilliant yellow touch on the hat of the lady second from the left. But the painting is simply an impression of people at the seaside; their faces are patches of pinkish buff with no attempt at definition.

Margaret Davies bought *Beach at Trouville* from the Lefevre Gallery, London, in April 1924.

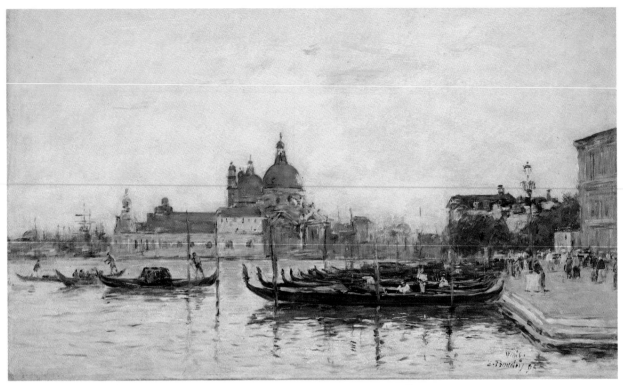

**29 Venice, the Jetty at the mouth of the Grand Canal**
1895, oil on canvas, 14 x 22½ ins., 35.6 x 57 cm

Boudin painted this picture near the end of his life. In the middle is Santa Maria della Salute with, to the right, the opening of the Grand Canal; on the right of the painting are the Giardinetti and the beginning of the Piazzetta leading through to St. Mark's. The painting has none of the rich colour of Turner's or Monet's views of Venice; the sky is a creamy buff and the predominant tone of the rest of the painting is grey. The Davies papers include a letter from Boudin, written in Venice in 1895, which exactly expresses the view of Venice shown in this picture: 'Today a storm wraps everything with a grey, dull vapour, a thing we still see fairly often, though sometimes the sun shines and even gives a little warmth – but these waters, which don't resemble those of the Mediterranean, are mostly green and do not differ from our waters of the Channel.'

Gwendoline Davies bought *Venice, the Jetty at the mouth of the Grand Canal* from the Durand-Ruel Gallery, Paris, in October 1912.

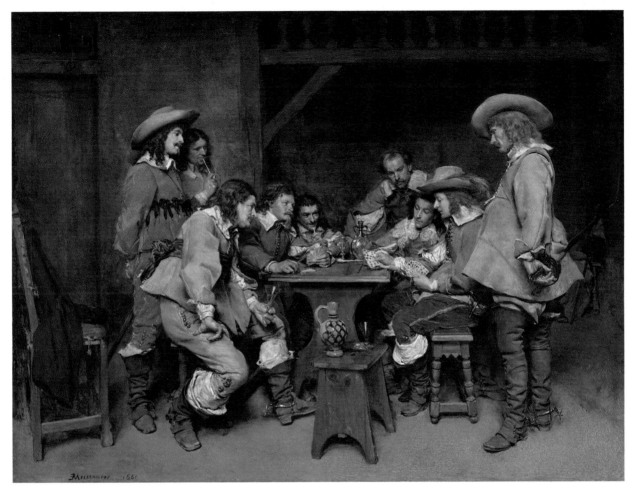

**30 A Game of Piquet**

1861, oil on panel, 11½ x 14½ ins., 29.3 x 36.7 cm

A work by Meissonier is an exception in the Davies collection, since it represents a kind of painting which, unlike the work of the Impressionists, was well received at the annual Salon and which has not risen in reputation in this century. Indeed Meissonier achieved enormous popularity under the Second Empire with works such as this one: small historical genre pieces, generally set in the Louis XIII period and always highly finished. One may, perhaps, see a connection between their popularity and that of the novels of Alexandre Dumas.

Margaret Davies bought *A Game of Piquet* from the French Gallery, London, in March 1910.

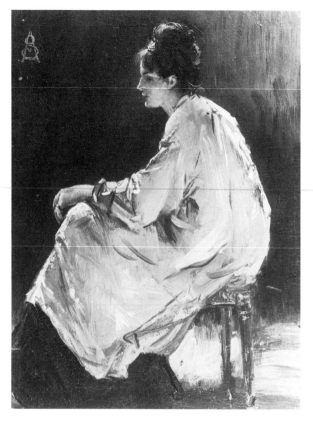

**31 Seated Girl**
Oil on canvas on panel, 8⅛ x 6⅜ ins., 20.6 x 16 cm

The Belgian-born painter Alfred Stevens came to Paris in 1844 and became, under the Second Empire, the fashionable painter of well-dressed women, set in elegant interiors. This freely painted sketch has none of the detail and anecdote of his highly finished interior scenes and, with the large area of white formed by the girl's shift, is reminiscent of Manet, who was a friend of Stevens.

Margaret Davies bought *Seated Girl* from the French Gallery, London, in January 1918.

**32 The Artist's Model**
Oil on panel, 9⅜ x 6⅜ ins., 23.8 x 16.2 cm

This painting must be a sketch for a larger picture, since Bargue normally practised a high finish in his paintings. As with Meissonier the figures are in period costume, but here it is that of the mid-18th century; the painter, whose hair is drawn into a pigtail, is seated on a Rococo-style chair. The French Rococo period, out of favour in the early 19th century, was beginning to arouse interest among collectors by the late 1850s.

Margaret Davies bought *The Artist's Model* from Wallis and Son, Pall Mall, in July 1910.

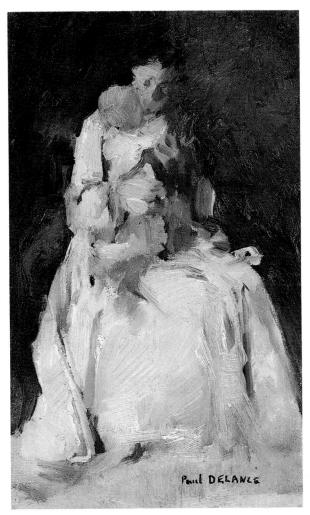

### 33 Mother and Child

Oil on canvas, 10¼ x 6⅛ ins., 26 x 15.5 cm

Paul Delance was a pupil of Jean Léon Gérome, the successful painter of historical subjects and oriental scenes. While Delance himself sometimes painted religious subjects, he also painted landscapes in the open air and charmingly straightforward oil sketches like this one, which may well be of the artist's wife and daughter.

Margaret Davies bought *Mother and Child* in December 1958 from Rowland, Browse and Delbanco, who had recently acquired it from the artist's daughter.

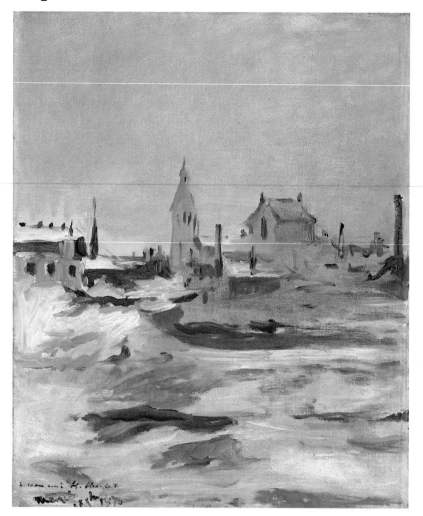

**34  The Church of Petit-Montrouge, Paris**
1870, oil on canvas, 23½ x 19½ ins., 59.7 x 49.5 cm

Petit-Montrouge is the name given to an area south of Montparnasse, between the Place Denfert-Rochereau and the Porte d'Orléans and distinct from the suburb of Montrouge outside the city which is known as Grand-Montrouge. This oil sketch was painted during the winter of 1870 when Manet was serving as a lieutenant in the National Guard as a result of the Franco-Prussian war. It is dated 28th December 1870 and has a dedication, possibly added later, 'à mon ami H. Charlet', presumably to a comrade in arms. The sketch is very much a winter scene, the colours being limited to black, brown, buff and white.

Gwendoline Davies bought *The Church of Petit-Montrouge* from the Durand–Ruel Gallery in Paris in October 1912.

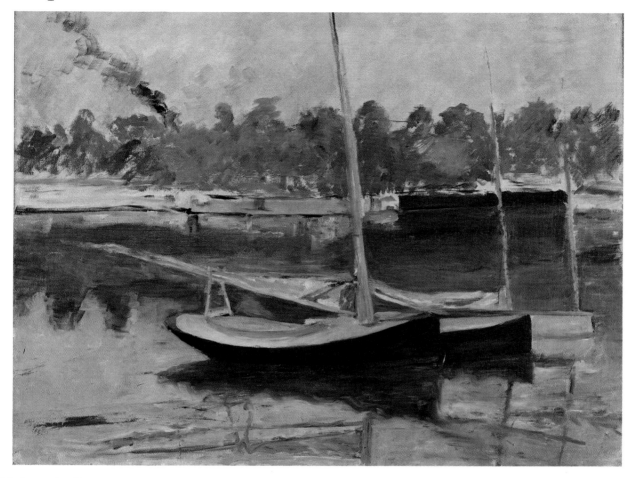

**35 Argenteuil**

1874, oil on canvas, 23¼ x 32 ins., 59 x 81.3 cm

Argenteuil is on the Seine, about ten miles downstream from Paris, and was a popular boating resort for Parisians in the late 19th century. Manet stayed near it for the summer season of 1874; at the same time Monet and his family were living there in a house found for them by Manet and they were visited that summer by Renoir. There are, thus, numerous paintings of Argenteuil by the three great painters and one by Manet, *Banks of the Seine at Argenteuil* in the Courtauld Institute Galleries, London, has the same two yachts as the Davies picture, but seen from further away and with a bank in the foreground with two figures on it, probably Madame Monet and her son Jean.

Margaret Davies bought *Argenteuil* from the Bernheim-Jeune Gallery in Paris, in April 1920.

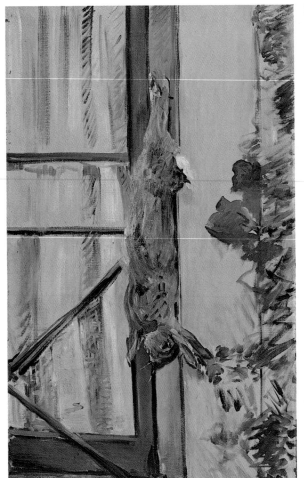

### 36 The Rabbit

1881, oil on canvas, 37 x 23 ins., 94 x 58.4 cm

This is one of a series of six decorative panels by
Manet, all of flowers, gardens or dead game. Four of
them were painted in the year 1881: *The Rabbit* (also
known as *The Hare*), *The Eagle Owl*, *Plants on a
Trellis* and *Corner of a Garden*. The rabbit hanging
from a nail outside a closed window is painted very
freely and with considerable virtuosity, but it is
impressionistic in the traditional, non-specific sense;
this sort of brushwork can be found in the paintings of
Velazquez or Frans Hals. In the same way the subject
of dead game is a traditional one, much painted in
18th century France by specialist painters like Oudry
and Desportes.

Gwendoline Davies bought *The Rabbit* from the
Bernheim-Jeune Gallery in Paris in December 1917.

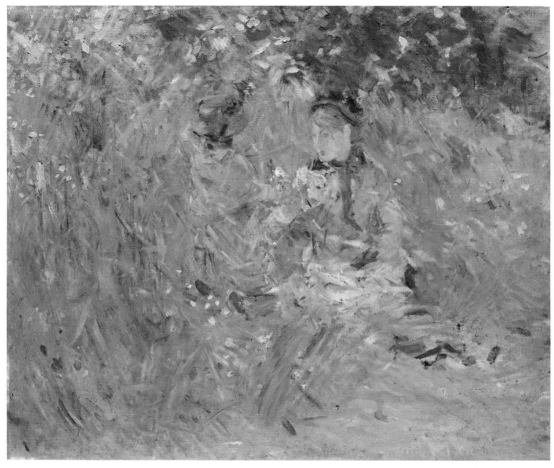

**37 Woman and Child in the garden at Bougival**
1882, oil on canvas, 23½ x 28¾ ins., 59.6 x 73 cm

Berthe Morisot, the only woman among the Impressionist painters, was influenced both by Corot, whom she knew from about 1862, and by Manet, whom she and her sister Edma met while copying Old Master paintings in the Louvre. In 1874 she married Manet's younger brother, Eugène. In 1881 Eugène Manet rented a house at Bougival, ten miles west of Paris, and in the summers of 1881 and 1882 Berthe Morisot, who continued to paint under her maiden name, painted many pictures there, of which this is one. The two figures are probably Julie Manet, Berthe Morisot's daughter, born in 1878, and her maid Paisie. The picture is reminiscent of Corot, both in the idyllic quality of the scene and in the touch of red on the maid's hat and scarf.

It is not known exactly when Margaret Davies bought *Woman and Child in the garden at Bougival*; former employees can remember it hanging in her bedroom before 1939.

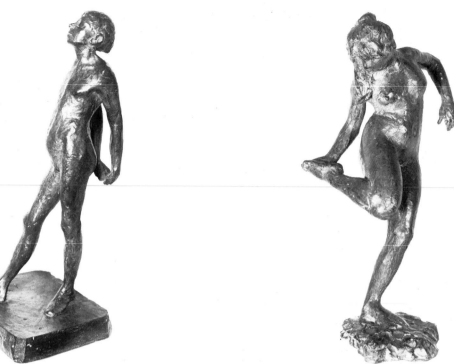

**38  Study for the dressed dancer**
Bronze, 28 ins., 72.4 cm high

The original clay model for this bronze was modelled
by Degas in 1879–80; it was a prototype for his most
famous statuette, *The fourteen year old Dancer*,
exhibited at the Impressionist Exhibition of 1881,
which was made of tinted wax, had real hair and was
dressed in real tutu, bodice and satin shoes. This
study is smaller than the wax statuette, 28½ inches
high instead of 39, and like Degas's other bronzes was
cast in an edition of twenty-two by the bronze founder
Hébrard between 1919 and 1921. After the casts had
been made, the original model was destroyed.

Gwendoline Davies bought *Study for the dressed
dancer* from an exhibition of Degas sculptures at the
Leicester Galleries, London, in March 1923.

**39  Dancer looking at the sole of her right foot**
Bronze, 18 ins., 45.7 cm high

The clay model for this statuette was modelled
rather later than *Study for the dressed dancer*,
probably around 1890, and the modelling has become
rougher. The figure here is a mature one and it is
evidently the problem of balance which fascinated
Degas. The pose recurs in several of his works; in
1977 the Museum purchased a pastel, *Woman in the
Bath*, which shows a figure in very much the same
pose, except that she is lifting her right foot out of a
bath tub, rather than looking at it.

Gwendoline Davies bought *Dancer looking at the
sole of her right foot* from an exhibition of Degas
sculptures at the Leicester Galleries, London, in
March 1923.

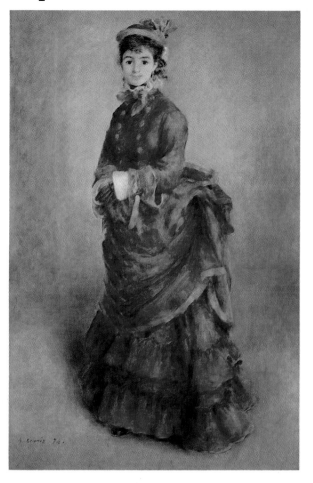

## 40 The Parisian Girl

1874, oil on canvas, 63 x 41½ ins., 160 x 105.4 cm

Renoir exhibited six oil paintings and one pastel at the First Impressionist Exhibition in 1874; this portrait was one of the oils. The woman portrayed was an actress, Madame Henriette Henriot, a favourite model of Renoir's in the years 1874–6. Although the figure has no real setting, and indeed only the semblance of a shadow to support her, it seems that she is about to go out, as she is pulling on her right glove. It is difficult now to understand the objections raised in 1874 to such a charming portrait, but the greatest objection was probably to the lack of finish, which, together with the general brightness of tone, is what gives the painting its peculiar vibrancy.

Gwendoline Davies bought *The Parisian Girl* from the National Portrait Society's exhibition at the Grosvenor Gallery in March 1913.

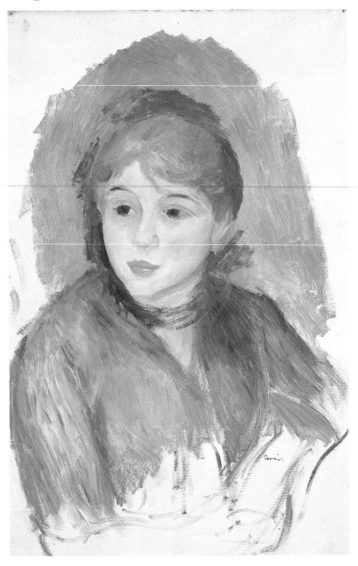

**41 Head of a Girl**
About 1882, oil on canvas on board, 21½ x 14 ins.,
54.5 x 35.5 cm

This sketch is characteristic of Renoir's 'dry' manner
of the 1880s; the colours have become cooler and the
general texture harder. The sketch is painted on a
canvas primed with white lead paint, so that the

tonality is extraordinarily cool and light.

Margaret Davies bought *Head of a Girl* from the
Roger Marx sale in Paris, in March 1914.

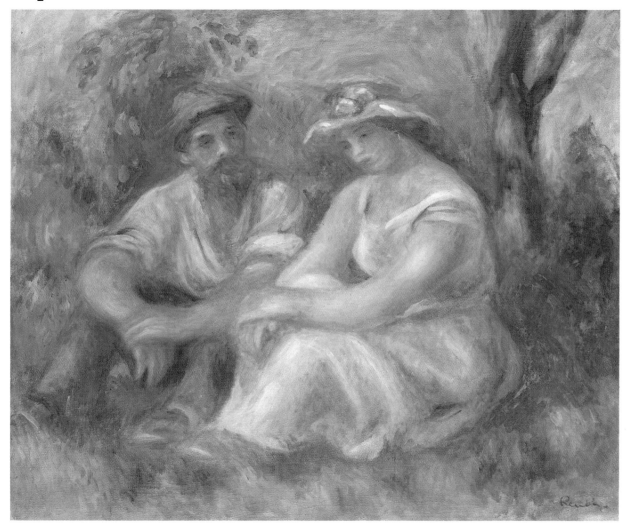

**42 Seated Couple**

1912, oil on canvas, 20½ x 25 ins., 52 x 63.5 cm

In 1898 Renoir bought a house at Essoyes, not far north of the wine-growing area of Burgundy, and took to spending the summer there. This picture was certainly painted in Renoir's garden at Essoyes, which had an old apple tree with a leaning trunk, which appears on the right of the painting. This is a picture from Renoir's old age and, if one compares it with the other two Davies Renoirs, it is evident how much hotter Renoir's colour has become; there is a great deal of red, both in the figures and in the landscape.

Gwendoline Davies bought *Seated Couple* from the Bernheim-Jeune Gallery in Paris, in December 1917.

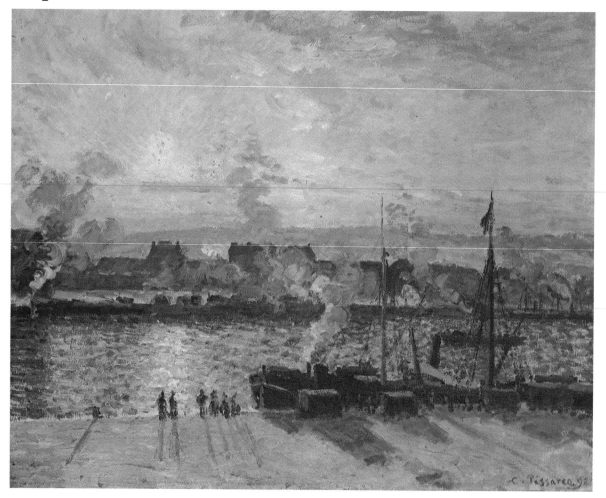

**43 Sunset at Rouen**

1898, oil on canvas, 25½ x 32 ins., 65 x 81 cm

Pissarro first worked in Rouen in 1883. In 1884 he moved from Osny, near Paris, to the village of Eragny, which is only about thirty miles east of Rouen. He spent more time painting at Rouen in both 1896 and 1898. This view of the Seine at Rouen, seen against the setting sun, would have been painted from the window of an hotel. From 1889 onwards Pissarro suffered from an infection of the tear duct which made it troublesome for him to work in the open air. Both the Davies Pissarro oils are examples of the cityscapes which he painted from upper windows as a consequence of this disability.

Margaret Davies bought *Sunset at Rouen* from the Pissarro exhibition at the Leicester Galleries, London, in June 1920.

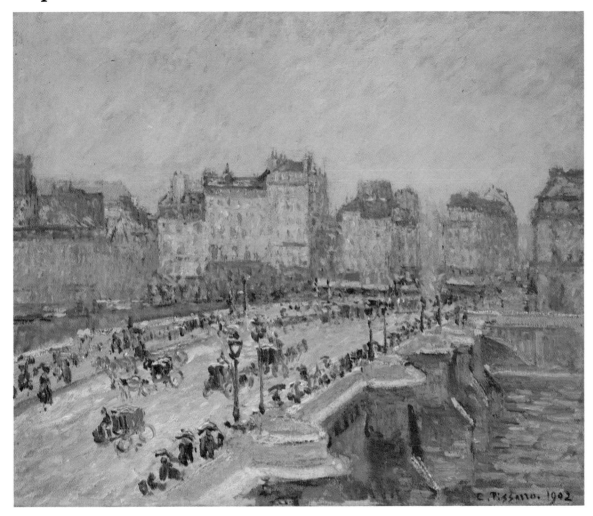

## 44 Pont Neuf, Paris, effect of snow

1902, oil on canvas, 21½ x 25½ ins., 54.6 x 65 cm

In contrast to the rich sunset of the previous painting the light in this Pissarro has the dead quality of a snowy day in a city. In the winter of 1900 Pissarro rented an apartment at 28 Place Dauphine, one of the old houses on the north side of the Ile de la Cité, just by the Pont Neuf. He continued to paint there in early 1901 and then returned in the early part of 1902,

the date of this picture. We are looking north in this view at the section of the Pont Neuf which joins the Ile de la Cité to the right bank of the Seine.

Margaret Davies bought *Pont Neuf, Paris, effect of snow* from the Pissarro exhibition at the Leicester Galleries, London, in June 1920.

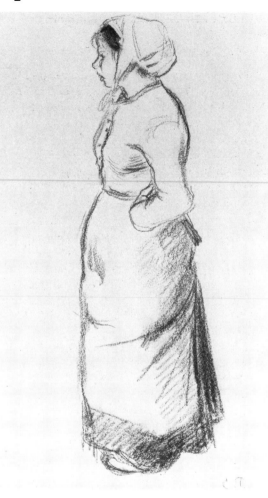

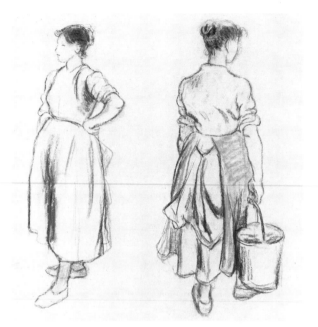

**46 Two Peasant Girls**

About 1890, black chalk and ochre chalk on pink
paper, 18 x 17¼ ins., 45.7 x 43.7 cm

The outlines of the two girls in this drawing have
been executed in black chalk, while the ochre chalk
has been used for shading. It is the poses of the
figures which interested Pissarro; the faces are
glossed over. The obvious antecedent for these
Normandy figure studies, with their absence of
individualisation and anecdote, are the drawings of
peasants by Jean-François Millet, who had died
fifteen years before.

Margaret Davies bought *Two Peasant Girls* from
the Pissarro exhibition at the Leicester Galleries,
London, in June 1920.

**45 Peasant Girl**

About 1890, black chalk on grey paper, 15 x 9½ ins.,
38.1 x 24 cm

This study, and the following one, would have been
drawn at Eragny, the Normandy village to which
Pissarro had moved in 1884. The girl here is more
individualised than the two in the following drawing,
in that her profile is quite clearly defined.

Margaret Davies bought *Peasant Girl* from the
Pissarro exhibition at the Leicester Galleries, London,
in June 1920.

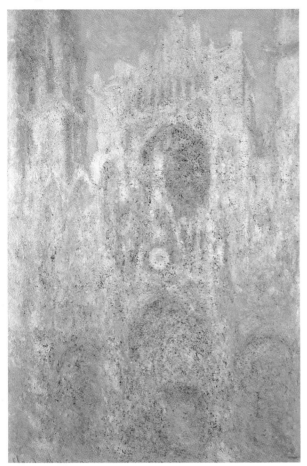

**47 Rouen Cathedral, Sunset, Symphony in Grey and Pink**
1894, oil on canvas, 39 x 25 ins., 99 x 63.5 cm

Monet first began painting series of paintings of the same object in 1890; the *Haystacks* series dates from 1890–1. Rouen Cathedral, a much more majestic object than a haystack, was the subject of his third series; at least thirty paintings of it still survive. Monet worked at Rouen in February 1892 and February 1893, painting from the window of a milliner's shop overlooking the cathedral. He kept a large number of canvases on hand, choosing the one to work on according to the light and weather conditions outside. The series was completed at Monet's home at Giverny in 1893–4 and twenty canvases from it were exhibited at the Durand-Ruel Gallery in Paris in May 1895. The best collection of Rouen Cathedral paintings today is that belonging to the Louvre which is exhibited in the Musée du Jeu de Paume.

Gwendoline Davies bought *Rouen Cathedral* from the Bernheim-Jeune Gallery in Paris, in December 1917.

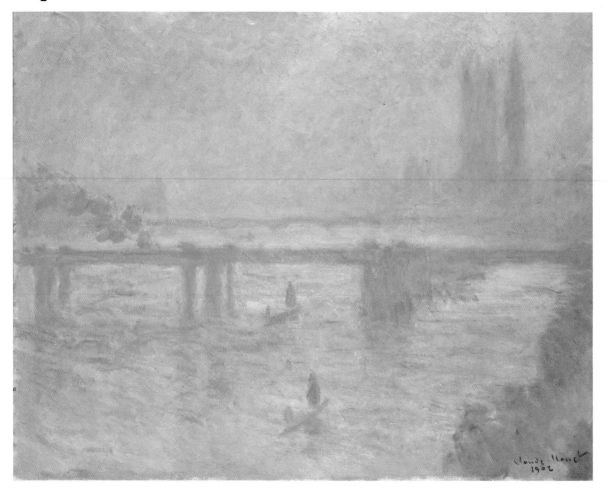

**48 Charing Cross Bridge, London**
1902, oil on canvas, 25¾ x 32 ins., 65.4 x 81.3 cm

Monet began his Thames series of paintings in the Autumn of 1899, working mainly from a fifth floor balcony of the newly-constructed Savoy Hotel. There are, in fact, three series of Thames views: the view upstream from the Savoy, as here, showing Charing Cross Bridge and the Houses of Parliament in the distance, the view downstream, showing Waterloo Bridge, and the view across the river of the Houses of Parliament, which he painted from St. Thomas's Hospital on the other bank. Monet returned to London to work on the three series in February 1900 and was again in London working on them between February and April 1901. He completed the three series from memory at Giverny in 1902–4 and it is thus that the Davies picture is dated 1902.

Margaret Davies bought *Charing Cross Bridge* from Wallis and Son, Pall Mall, in May 1913.

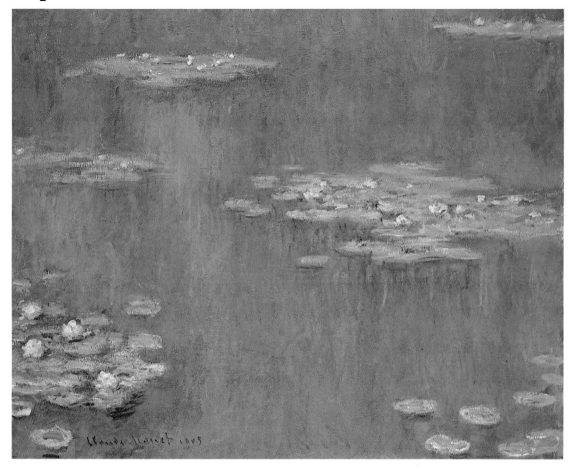

**49 The Water-lilies**

1905, oil on canvas, 31 x 38 ins., 78.7 x 96.5 cm

In 1890 Monet bought the house at Giverny, forty miles north-west of Paris, which was to be his home for the rest of his life. In 1893 he purchased a large pond, just across a single track railway line from the garden of his house, and this and the surrounding area he transformed into the water garden which was to become the principal subject of his late paintings. Over one end of the pond he had a Japanese bridge constructed, which enabled him to look down on the surface of the pond. It is because of this high viewpoint that the picture plane rises so steeply in all the Davies *Water-lilies*; in the 1908 version it seems to rise almost vertically. The Japanese bridge also gave Monet a view of the pond in which the banks could be ignored; no shoreline appears in any of these paintings. Monet's *Water-lilies* are in fact the nearest that any Impressionist painter came to abstract art.

Gwendoline Davies bought the three *Water-lilies* paintings from the Bernheim-Jeune Gallery in Paris, in July 1913.

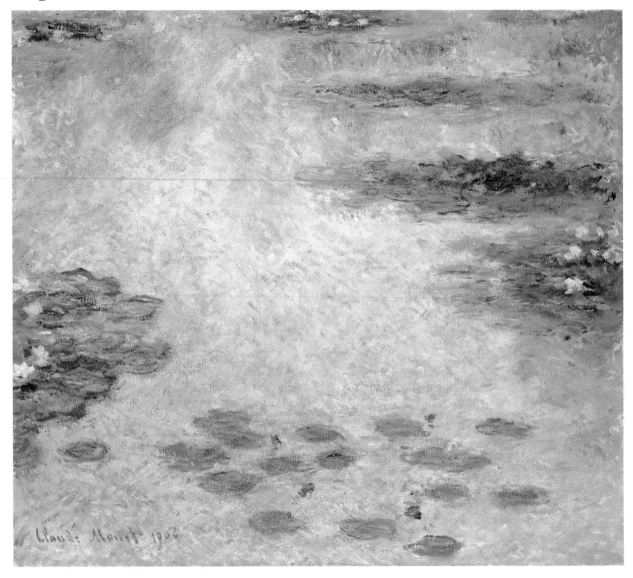

**50 The Water-lilies**
 1906, oil on canvas, 31 x 35 ins., 78.7 x 88.9 cm

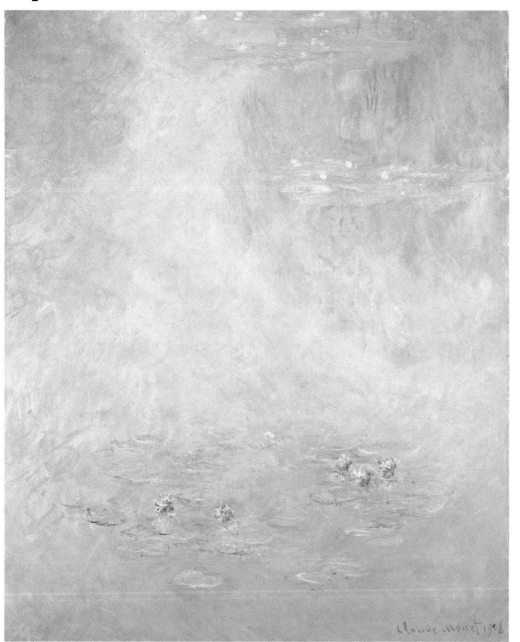

**51 The Water-lilies**
1908, oil on canvas, 38 x 31 ins., 96.5 x 78.7 cm

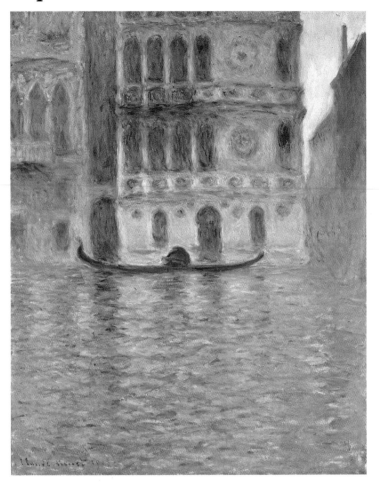

**52 Palazzo Dario, Venice**
1908, oil on canvas, 36³⁄₈ x 29 ins., 92.3 x 73.6 cm

Monet and his wife visited Venice from September to December 1908. Monet had been reluctant to visit a city painted by so many earlier painters, but, once there, he was very much moved by what he saw. The Palazzo Dario is a Gothic palace of varicoloured marble on the south bank of the Grand Canal. It is situated near the bottom end of the canal, not far from Santa Maria della Salute. Monet accepts in this picture the rather awkward viewpoint imposed on

him by the relative narrowness of the Grand Canal, but the cutting off of the palace at the top and the inclusion of part of the one next door must owe something to the example of Japanese prints, in which forms are often cut in half by the edge of the print. Monet had a collection of such prints at Giverny.

Margaret Davies bought *Palazzo Dario, Venice* from the Durand-Ruel Gallery in Paris in July 1913.

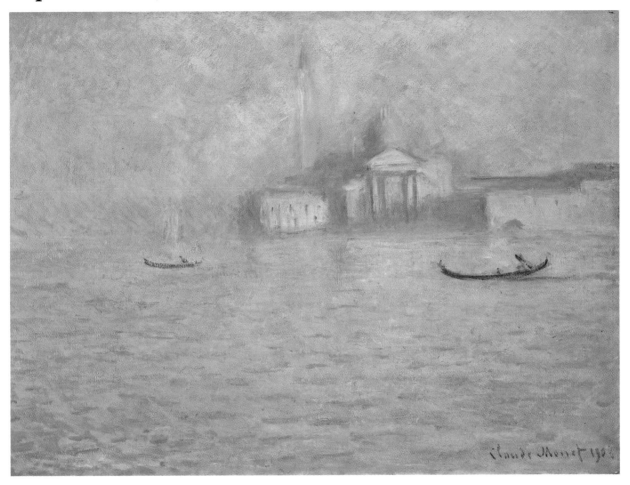

## 53 San Giorgio Maggiore

1908, oil on canvas, 22 x 31 ins., 55.9 x 78.7 cm

Palladio's famous church on its island, seen from the Riva on the other side of the Basin of St. Mark's, is like a ghostly presence in what appears to be evening light: the façade is lit slantingly from the west. In colour the painting is surprisingly close to *Charing Cross Bridge*. Monet painted both maritime cities during the winter months and probably there were moments when the light and atmosphere were similar in the two places.

Gwendoline Davies bought *San Giorgio Maggiore* from the Bernheim-Jeune Gallery in Paris in October 1912.

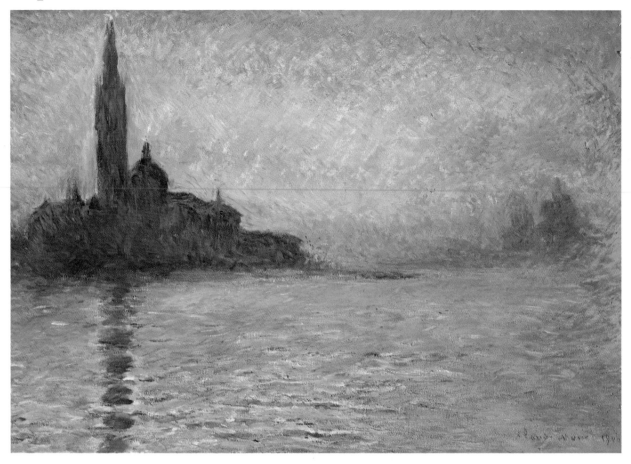

**54 Twilight, Venice**
1908, oil on canvas, 25 x 35 ins., 63.5 x 88.9 cm

This, too, is a view of San Giorgio Maggiore, but whereas the previous painting showed the façade, seen from the north, this painting looks west at the side of the church seen against the sunset. On the right of the painting the dome of Santa Maria della Salute at the mouth of the Grand Canal can be discerned. This painting and the one before were purchased by Gwendoline Davies only four years after Monet had painted them; she was thus buying virtually the most recent Monets available.

Gwendoline Davies bought *Twilight, Venice* from the Bernheim-Jeune Gallery in Paris in October 1912.

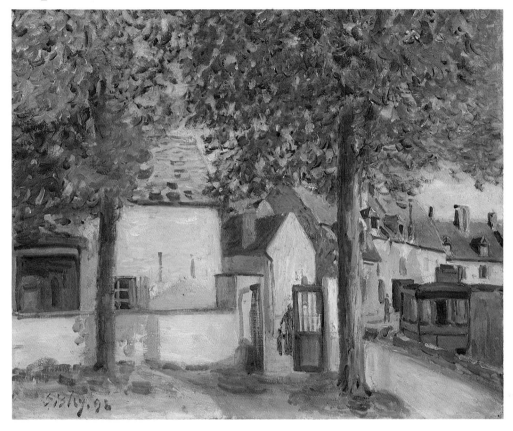

**55 View in the Village of Moret**

1892, oil on canvas, 15 x 18½ ins, 38 x 47 cm

Like the other Impressionists Sisley moved away from Paris in the 1880s; in 1889 he settled in Moret-sur-Loing, a village a few miles south of Fontainebleau. The village and the river Loing which flows through it became the principal subjects of his late paintings. Sisley's colour, like that of the other Impressionists, becomes brighter and warmer in his later works; the roofs of the houses in this painting have a great deal of pink in them and there is red in both the trunks and the foliage of the trees.

Margaret Davies bought *View in the Village of Moret* from the O'Hana Gallery, London, in September 1960.

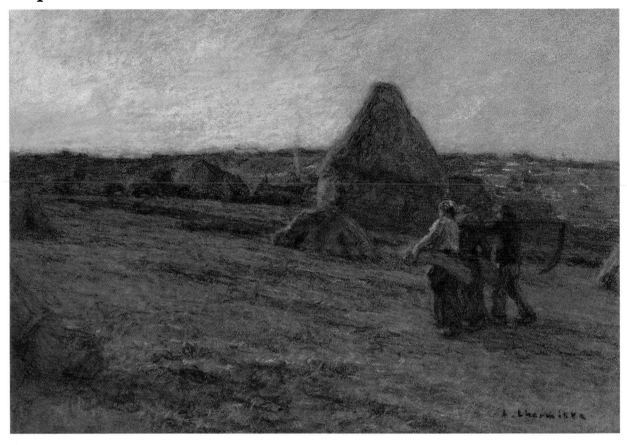

**56 Return of the Harvesters**
Pastel, 10¾ x 14½ ins., 26 x 36.7 cm

Lhermitte was an exact contemporary of the principal Impressionists, but, although influenced by them in the light tonality of his pictures, he cannot really be considered one of them. He shares neither their research into the nature of colour nor their absence of sentimentality. The main influence on his subject matter was, of course, the peasant subjects of Jean-François Millet and Lhermitte benefitted from the great interest which Millet's works aroused after his death and from the high prices paid for them. He was a very successful artist in his lifetime, but his peasants appear timid next to those of his contemporary, Pissarro (see Nos. 45, 46).

Margaret Davies bought *Return of the Harvesters* from Arthur Tooth and Son, London, in July 1912.

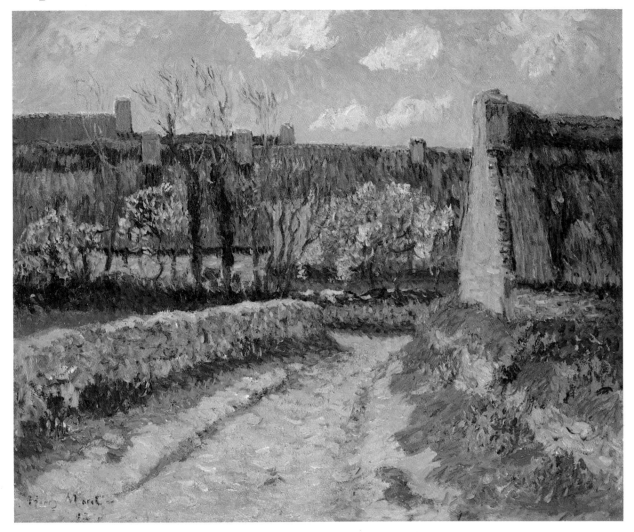

**57 Village in Clohars**
1898, oil on canvas, 21½ x 25⅝ ins., 54.6 x 65.1 cm

Clohars is near Pont Aven on the south coast of the Brittany peninsula. After an academic training in Paris Moret went to Brittany in 1889 and painted with the group of painters who had gathered round Gauguin at Pont Aven. The strong colours in this picture reflect the theories of Gauguin; the greens, for example, are as brilliant as possible. The thatched Breton village makes an interesting contrast with the much neater Ile de France village in the picture by Sisley.

Margaret Davies bought *Village in Clohars* from Arthur Tooth and Son, London, in December 1959.

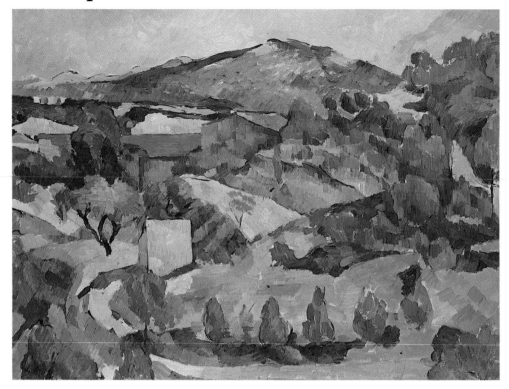

**58 Mountains at L'Estaque**
1878–80, oil on canvas, 21 x 28½ ins., 53.3 x 72.4 cm

Unlike the Impressionists Cézanne was a Southerner, the son of a banker in Aix-en-Provence. Although he was closely associated with the Impressionists in Paris in the 1860s and early 1870s, from 1875 onwards he began to spend more and more time in the south, mostly at Aix, but also at L'Estaque, a small village by the sea near Marseilles. Most of his paintings of L'Estaque show a much wider sweep of the Bay of Marseilles, but here a low hill on the right obscures all but a tiny glimpse of the bay in the upper left of the picture. The painting is quite difficult to read, as it is painted from a high viewpoint so that distant objects which are in fact low down appear high up on the canvas. Furthermore, distant objects are just as clear and bright as foreground ones. Cézanne used clear touches of colour like the Impressionists, but with the opposite effect: to achieve solidity rather than the dissolution of forms in light and atmosphere. In June 1922 the loan of this painting, originally offered to the Tate Gallery in January 1921 by Hugh Blaker acting on behalf of Gwendoline Davies, was accepted by the Gallery's Trustees. It was thus the first painting by Cézanne to be shown in a public gallery in Great Britain and it was admired there by Samuel Courtauld, who was soon to form his own collection of modern French art.

Gwendoline Davies bought *Mountains at L'Estaque* from the Bernheim-Jeune Gallery in Paris in February 1918.

**59 Provençal Landscape – the Copse**
About 1888, oil on canvas, 31½ x 24¼ ins.,
80 x 61.6 cm

This study of trees was probably painted at the Jas de Bouffan, a thirty-seven acre estate just outside Aix which Cézanne's father had bought in 1859 and which Cézanne had inherited on his father's death in 1886. This is a much slighter painting than *Mountains at L'Estaque*, indeed it could be called an oil sketch, the ground of the picture being barely covered in places at the top of the trees. The brush strokes are much freer than in the earlier painting and run at different angles on the different trees, although they are still laid on parallel to one another. The appeal of the painting undoubtedly lies in its colour, the combination of orange-brown foreground with the bluish-green foliage and purplish trunks of the trees being extraordinarily beautiful.

Gwendoline Davies bought *Provençal Landscape- the Copse* from the Bernheim-Jeune Gallery in February 1918.

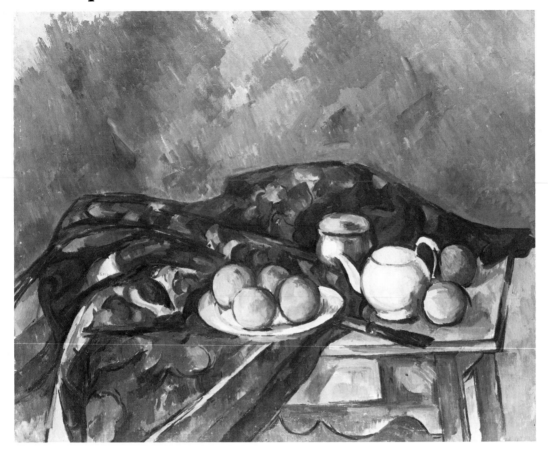

**60  Still Life with a Teapot**
1902–6, oil on canvas, 23 x 28 ½ ins., 58.4 x 72.4 cm

Different dates have been assigned to this painting, the winter of 1898–9, which Cézanne spent in Paris, and more recently 1902–6, which would mean that it was painted at Aix-en-Provence. A number of still life paintings by Cézanne show this table, recognisable by the waved edge of its underframe; it survives in Cézanne's studio at Aix. The patterned cloth is sometimes shown bunched on the table like this, giving it an outline rather like the Provençal mountains Cézanne painted so often, and sometimes draped as a curtain behind the table. As in other still life paintings by Cézanne the perspective is altered here so as to show more of the top of the table than we would really see. This can be seen most clearly on the right where the edge of the table and the underframe are far from being parallel. Cézanne goes beyond realism, too, in omitting the knob of the teapot lid, the better to emphasise the relationship of its spherical shape with those of the oranges next to it.

Gwendoline Davies bought *Still Life with a Teapot* from the Bernheim-Jeune Gallery in Paris in March 1920.

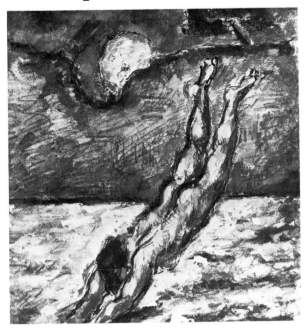

**62 The Three Bathers**
1875–7, pencil, watercolour and gouache, 4½ x 5 ins.,
11.4 x 12.7 cm

### 61 Woman Diving Head First
1867–70, pencil, watercolour and gouache, 5 x 4¾ ins.,
12.7 x 12.1 cm

In his monumental two-volume work on Cézanne
Lionello Venturi entitled this watercolour 'The Fall of
Icarus'. In 1967 John Ingamells gave it back its
present title, which was the one given to it by the
dealers, Bernheim-Jeune, in 1919. Although the sex of
the figure may be ambiguous, there is no sign of
wings, which would be the attribute of Icarus, and the
figure appears to be diving rather than falling. The
scene also seems to be a nocturnal one, with the sky a
very dark blue and the water highlighted with a great
deal of Chinese white to give it the appearance of a
moonlit sea.

Gwendoline Davies bought *Woman Diving Head
First* from the Bernheim-Jeune Gallery in Paris in
March 1920.

The theme of the Bathers occupied Cézanne's mind
through most of his career and recurred particularly
strongly at the end of his life, notably in the *Grandes
Baigneuses* in the National Gallery, London. The use
of such a theme shows how close Cézanne was to the
Old Masters, to Giorgione, to Titian and particularly
to Rubens. The woman on the right, whose figure is
made up of counterbalanced curves, seems to show a
particular debt to the example of Rubens. The three
figures are worked out very thoroughly in pencil and
then coloured in with watercolour, but with much less
opaque watercolour than in *Woman Diving Head
First*.

Gwendoline Davies bought *The Three Bathers*
from the Bernheim-Jeune Gallery in Paris in
March 1920.

**63 Rain at Auvers**

1890, oil on canvas, 19 x 39 ins., 48.3 x 99 cm

In 1890 Van Gogh left the Saint Rémy asylum near Arles and, after a brief stay in Paris, came in May to Auvers-sur-Oise, about twenty miles north of Paris. He lodged at the Café Ravoux in the little town and was watched over by Dr. Gachet, to whom he had been recommended by Pissarro and whom he painted in a portrait now in Frankfurt. The Davies landscape shows the wheatfields, which were the principal feature of the area around Auvers, with the town itself tucked into the slight valley formed by the river Oise. The yellows in the painting are much paler than in Van Gogh's paintings of southern France, reflecting the colours of a rainy day in northern France. The graphic representation of the rain itself is derived from Japanese prints, particularly Hiroshige's *Ohashi Bridge in the Rain*, which was copied in oils by Van Gogh. This landscape was painted in July 1890 and on the 29th of that month, troubled by ill-health and tormented by the thought of being a financial burden to his recently-married brother, Theo, Van Gogh shot himself.

Gwendoline Davies bought *Rain at Auvers* from the Bernheim-Jeune Gallery in Paris in March 1920.

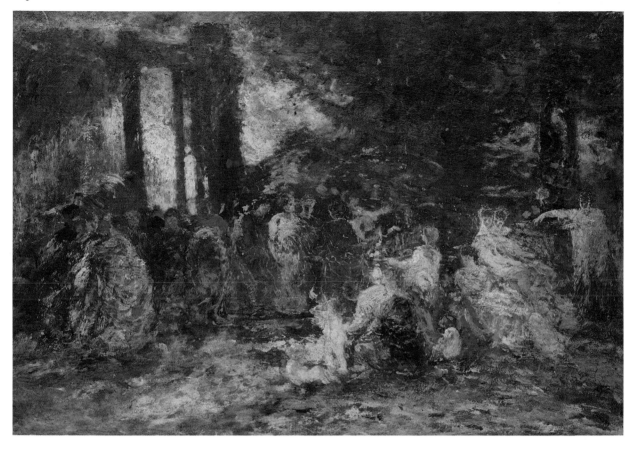

**64 A Summer Court**

Oil on panel, 15½ x 23 ins., 39.4 x 58.4 cm

Monticelli, who was born in Marseilles and spent much of his life there, had something in common with Diaz de la Peña in the choice of *fêtes champêtres* as subjects for his paintings. But his manner of painting is very different; the paintings of Monticelli depend for their impact on the surface excitement of the built-up paint. Contrary to popular belief Monticelli rarely used a palette knife, but rather a number of hard, short brushes; he would often wipe his paintings with a rag and sometimes spread the thick paint with his finger.

Gwendoline Davies bought *A Summer Court* from Wallis and Son, Pall Mall, in September 1913.

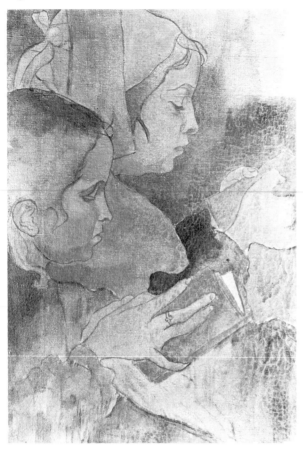

### 65 Breton Peasant Women

About 1894, oil on canvas, 21½ x 15 ins.,
54.6 x 38.1 cm

When Gwendoline Davies bought this painting it was
generally believed to be by Gauguin, a not
unreasonable belief since Gauguin in his Pont Aven
period painted a number of pictures of Breton women
at their devotions. In 1960, however, *Breton Peasant
Women* was reattributed to Armand Séguin a Paris-
trained painter who lived at Pont Aven from 1890 to
1894 and possibly longer. Séguin was one of the group,
influenced by Gauguin and Emile Bernard, who
called themselves Nabis, from the Hebrew word for
Prophet. Like Gauguin, Séguin divides his painting
into flat areas of strong colour, no doubt under the
influence of Japanese prints, and is not concerned
with an exact definition of space. It is not clear, for
example, whether the Breton girls are kneeling or
sitting; what is important is that the painting exalts
them as examples of the primitive and the
unsophisticated.

Gwendoline Davies bought *Breton Peasant
Women* from Mrs. Hilda Thornton of Bath in
July 1916.

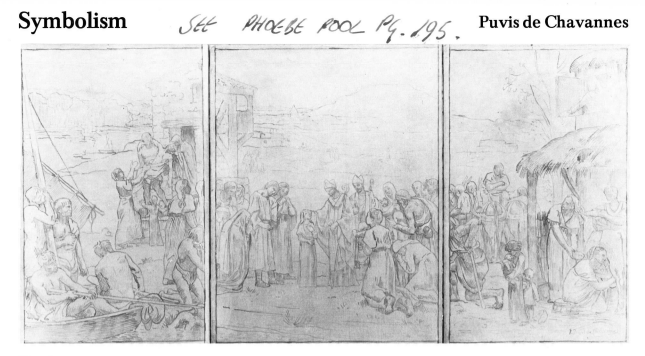

### 66 The Childhood of Saint Genevieve

About 1876, ink and bistre on canvas, 23 x 49½ ins.,
58.4 x 126 cm

This sketch in triptych form relates to the first cycle of frescoes which Puvis de Chavannes painted for the Panthéon in Paris, which had, up to the Revolution, been a church dedicated to Saint Genevieve, the 5th-century saint who is venerated as the patron saint of Paris. In 1874 the French Republic, which had taken over the church, commissioned a number of artists to undertake decorative panels for the walls; Puvis de Chavannes was allotted the subject of the childhood of Saint Genevieve. The centre of his composition shows Saint Genevieve at the age of six meeting Saint Germanus of Auxerre, who was passing through Nanterre, where Genevieve lived, on his way to England. Saint Germanus was so struck by the child's piety that he dedicated her to God and hung a medal with a cross round her neck.

Margaret Davies bought *The Childhood of Saint Genevieve* from the Bernheim-Jeune Gallery in Paris in March 1920.

*Look at. MOREAU.*

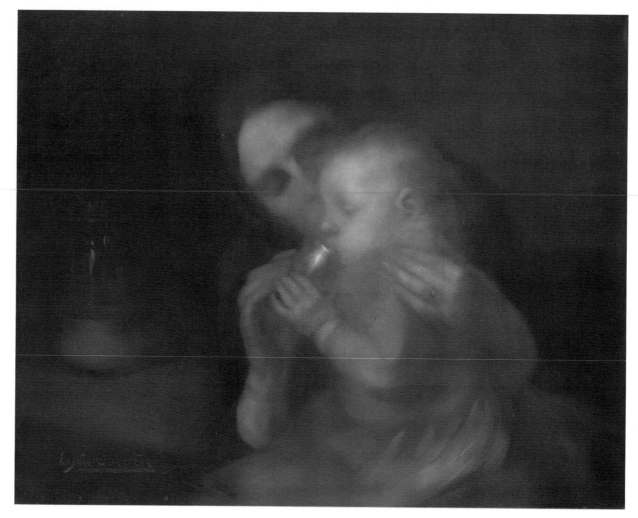

**67 The Tin Mug**

About 1888, oil on canvas, 22½ x 28½ ins.,
57.1 x 72.4 cm

Carrière was born in Strasbourg, but moved to Paris
in 1896 where the sight of the Rubens paintings in the
Louvre made him determined to become a painter.
While almost a contemporary of the Impressionists
he is quite different from them in his renunciation of
colour from about 1885 and in the limited range of his

subjects. The Davies collection is unique in Great
Britain in its representative showing of this largely
forgotten painter.

Gwendoline Davies bought *The Tin Mug* from the
Bernheim-Jeune Gallery in Paris in April 1917.

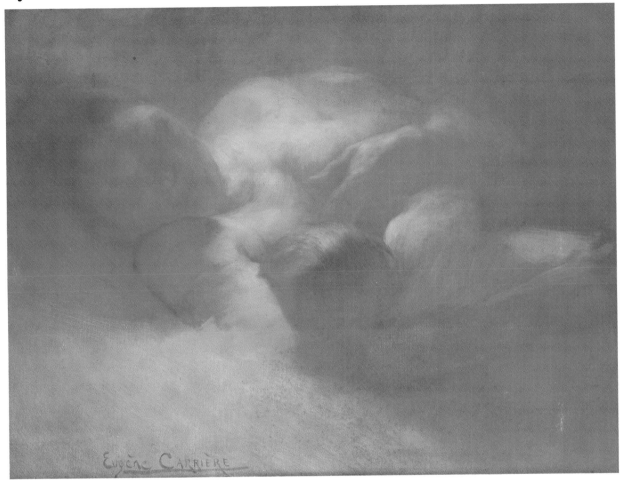

**68 Motherhood**
About 1888, oil on canvas, 21 x 28 ins., 53.3 x 71.1 cm

Madame Carrière was the model for all the mother and child pictures executed by her husband, yet a picture like this is quite unspecific and is far from being a portrait. It is the idea, indeed, the ideal of motherhood which is the subject of the painting.

Gwendoline Davies bought *Motherhood* from the Bernheim-Jeune Gallery in Paris in May 1914.

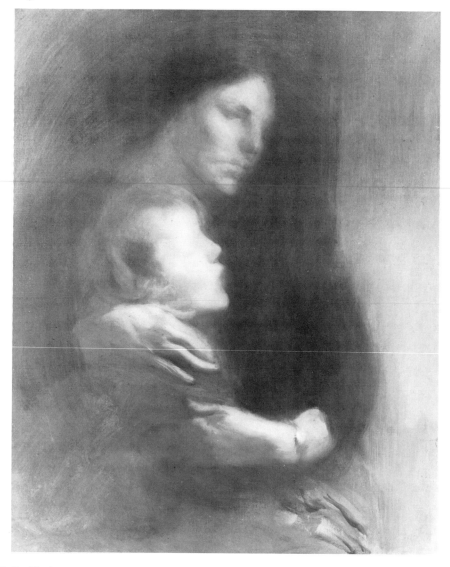

**69 Suffering**

1891, oil on canvas, 31 x 25 ins., 78.7 x 63.5 cm

This painting was called *Motherhood* (*Maternité*) by the Bernheim-Jeune Gallery, which held four Carrière exhibitions between 1901 and 1920. The subject is perhaps over-dramatised by calling it *Suffering*; it is a painting of a mother with her sick child and once again Madame Carrière is the model for the mother.

Gwendoline Davies bought *Suffering* from the Bernheim-Jeune Gallery in Paris in May 1913.

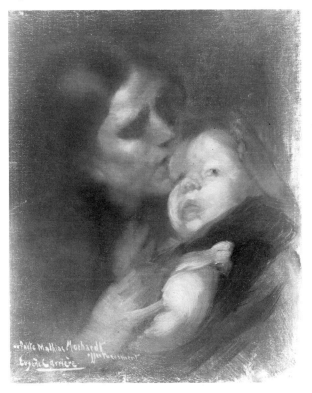

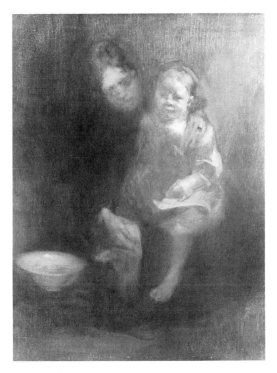

**71 The Footbath**
About 1890, oil on canvas 13 x 10 ins., 33 x 25.4 cm

This, the smallest of the Davies Carrières, has rather more suggestion of space than the others, with the mother and child shown full-length and at a greater distance from the picture plane. The foot bowl on a stool or ledge gives a point of reference for the eye as well.

Gwendoline Davies bought *The Footbath* from the Bernheim-Jeune Gallery in Paris in May 1913.

**70 Mother and Child**
About 1890, oil on canvas, 15 x 12 ins., 38.1 x 30.5 cm

This small painting, only two inches larger each way than *The Footbath*, is inscribed 'au poète Mathias Morhardt affectueusement' (to the poet Mathias Morhardt with affection). Mathias Morhardt wrote one of the very few articles in English on Carrière's work in *The Magazine of Art* on the occasion of the Carrière exhibition at the Continental Gallery, London, in 1898.

Gwendoline Davies bought *Mother and Child* from the Bernheim-Jeune Gallery in Paris in May 1914.

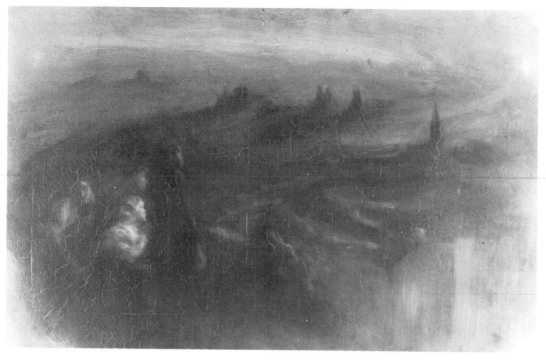

**72 Dawn**

About 1897, oil on canvas 15 x 24 ins., 38.1 x 61 cm

This rather enigmatic picture shows a family looking over a city at dawn from a nearby hill-top. It probably symbolises mankind's hope of a better future, combined with an emphasis on the family habitual with Carrière.

Gwendoline Davies bought *Dawn* from the Bernheim-Jeune Gallery in Paris in March 1920.

### 73 St. John the Baptist
1878, bronze, 81 ins., 206 cm high

The model for the figure of John the Baptist was an Italian called Pignatelli who appeared at Rodin's studio late in 1877 or early in 1878, seeking work as a model. The Italian had never posed before and, when asked to walk, made the movement shown in this figure. Albert Elsen has pointed out that if one allows one's eye to travel up the figure's left leg as far as the torso and then to descend the right leg, the figure appears to shift its weight, as though taking a step. In other words Rodin has shown two different movements, the left foot beginning the push off the ground and the right foot landing. In fact the very awkwardness of the pose contributes to the vigour of the sculpture. The figure originally carried a cross as an attribute of St. John the Baptist, but by the time it was exhibited at the Salon of 1880 Rodin had removed the cross as a distracting detail.

Margaret Davies bought *St. John the Baptist* from the Georges Petit Gallery in Paris in April 1913.

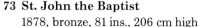

## 74 Eve

1881, bronze, 68 ins., 173 cm high

In 1880 the French government commissioned Rodin to sculpt a monumental portal with double bronze doors for the School of Decorative Arts in Paris. Rodin called the doors the *Gates of Hell*, in contrast to the early 15th-century bronze doors sculpted by Lorenzo Ghiberti for the Baptistery of Florence Cathedral, which are known as the *Gates of Paradise*. The *Gates of Hell* were never fully completed because of constant changes in the design. Indeed, this figure derives from an early idea, which was to have Adam and Eve flanking the doors. Later this was changed, but, as with so many figures from the *Gates, Eve* was made into a separate life-size figure. Her despairing pose and the fact that she is unfinished make her reminiscent of Michelangelo's *Captives*. Rodin pointed out, however, to one of his biographers that the unfinished state of the figure was not his fault; the model became pregnant and left before the sculpture was completed.

Gwendoline Davies bought *Eve* from Wallis and Son, Pall Mall, in July 1916.

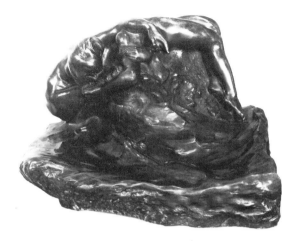

## 75 Eternal Spring
1884, bronze, 15½ ins., 39.4 cm high

This small group, which easily fits on a table top, derives in part from the *Gates of Hell*. The figure of the woman, with her torso thrown back, comes from the top left corner of the tympanum above the Gates. The man, however, is new. The original plaster of this group does not have the extensive base nor the rock-like support on the right; these were added to facilitate the casting of the man's outstretched arm and overhanging leg.

Gwendoline Davies bought *Eternal Spring* from the Leicester Galleries, London, in November 1912.

## 76 Illusions Fallen to the Earth
1895, bronze, 20½ ins., 53 cm high

A fuller title which has been given to this bronze is *Illusion falls with broken wings, the earth receives him*. The work is also known as the *Fallen Angel*, the cast of it formerly in the Victoria and Albert and now in the Bethnal Green Museum having that title. *Illusions Fallen to the Earth* is closely related to *Eternal Spring* (No. 75); the female figure with torso stretched back and legs limp was used in that group in an upright position and comes, of course, originally from the *Gates of Hell*. The original plaster for the present bronze is in the Musée Rodin in Paris.

Gwendoline Davies bought *Illusions Fallen to the Earth* from the Carfax Gallery, London, in September 1912.

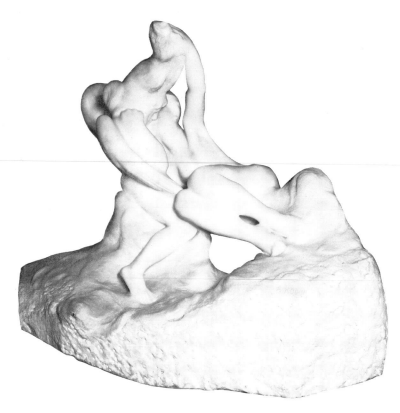

## 77 The Kiss

About 1885, marble, 40 ins., 102 cm long

Although this group is so similar to the other smaller Davies Rodins, showing, as it does, two figures locked in an embrace, the authorship of Rodin has at times been doubted. If Rodin did make the original model, it would still have been standard practice for the marble to be carved by another sculptor working under his supervision, Rodin being essentially a sculptor who modelled, rather than one who revealed form by carving away a block of stone. Nevertheless, this marble *Kiss* was exhibited as a Rodin at the Royal Academy in 1913 and it seems unlikely that Rodin, who had many British admirers by that stage of his career, would not have known about it.

The *Kiss* was bought for Gwendoline Davies by Hugh Blaker at the George McCulloch sale in May 1913.

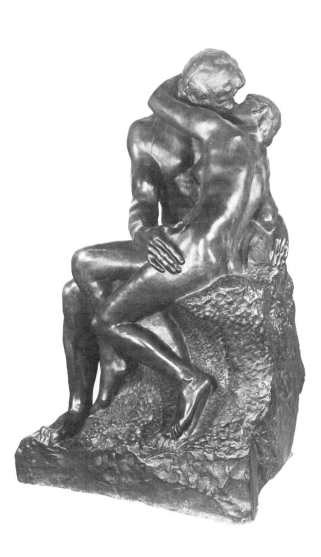

### 78 The Kiss

1888, bronze, 72 ins., 183 cm high

The large *Kiss* derives from a group from the lower
part of the left hand gate of the *Gates of Hell*; a clay
model for the *Gates* in the Rodin Museum at
Philadelphia shows this clearly. The group was
originally conceived as representing Paolo and
Francesca from Dante's *Inferno* (for the subject see
No. 17) and was thus a highly suitable subject for the
*Gates of Hell*. Later, however, a recumbent pair of
figures of Paolo and Francesca was substituted for
the upright one, which in 1886 was developed into a
half-life-size group. Then in 1888 Rodin was
commissioned by the French Republic to produce a
marble version of *The Kiss* on a scale larger than life;
four marbles were carved by other sculptors working
under Rodin's supervision and one of them is now in
the Tate Gallery, London. An edition of bronzes was
also cast by Alexis Rudier at an unknown date.

Gwendoline Davies bought *The Kiss* from the
Georges Petit Gallery in Paris in September 1912.

### 79 The Earth and the Moon
1899, marble 48½ ins., 123 cm high

This marble group seems more satisfying than the marble *Kiss* (No. 77), because the contrast between the massive block of marble and the slender, delicately carved figures is so striking. The upright female figure turned inwards is derived from the young girl who embraces an old woman in *Youth Triumphant* of 1894.

Gwendoline Davies bought *The Earth and the Moon* from Wallis and Son, Pall Mall, in July 1914.

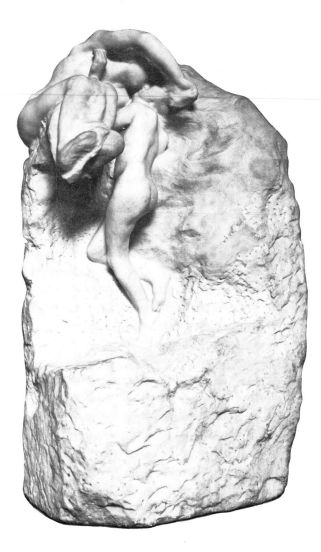

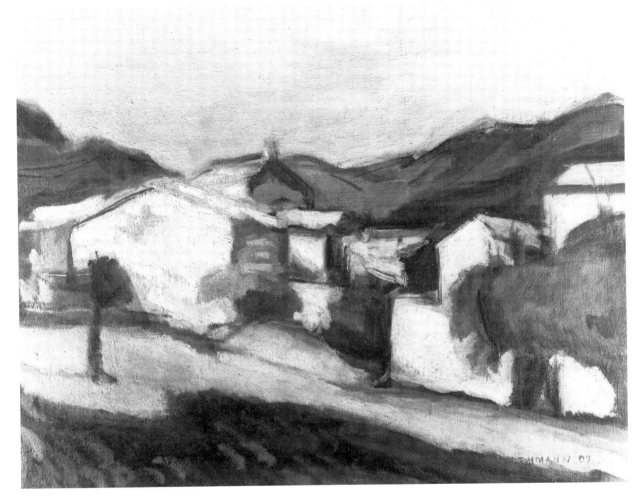

### 80 A House at Beaufort

1907, oil on canvas, 19¾ x 24 ins., 50.2 x 61 cm

Lehmann was born at Altkirch in Alsace at a time when that province had become part of the German Empire, following the French defeat in the Franco–Prussian war. He opted, however, for French nationality and came to Paris in 1891 to prepare for the Ecole des Beaux-Arts. Beaufort, the subject of this picture, is not in Alsace, but in the Jura much further south.

Margaret Davies bought *A House at Beaufort* from the Leicester Galleries, London, in March 1948.

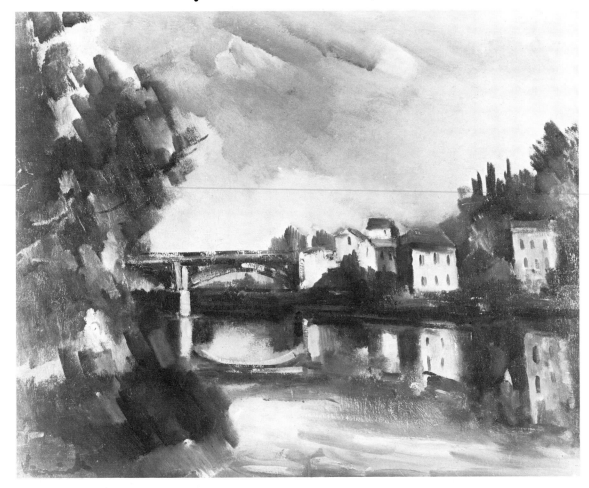

**81 The Bridge**

1912–1913, oil on canvas, 23½ x 28 ins., 59.7 x 72.4 cm

Vlaminck was one of the group of painters who were nicknamed the Fauves, or wild beasts, at the Salon d'Automne of 1905. The other best known painters in the group, whose pictures were distinguished by the intense strength and brightness of their colour, were Matisse, Derain, Friesz, Marquet and Van Dongen. By 1912, however, Vlaminck, like Derain, had abandoned very bright colours, although still using very strong blues and greens, as in this painting. In his use of parallel brush strokes, particularly in the trees on the left, Vlaminck is reminiscent of Cézanne, but without Cézanne's tight control of both structure and emotion. Indeed, the strong colours in Vlaminck's paintings are intended to arouse emotion.

Gwendoline Davies bought *The Bridge* from an exhibition at the Mansard Gallery, London, arranged by the Polish-born Parisian dealer, Zborowski.

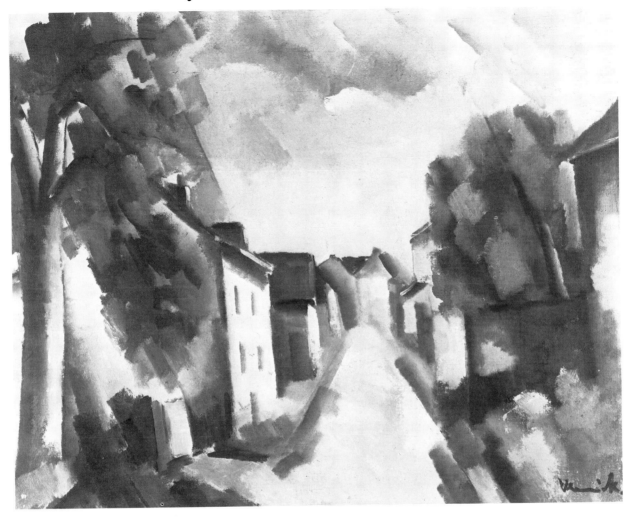

**82 Village Street**
1914, oil on canvas, 22½ x 28½ ins., 57.2 x 72.4 cm

This painting is much lighter in tone than *The Bridge,* only the trees and the shadows being relatively dark. The broad parallel brush strokes, all inclined towards the left, give a strong sense of movement to the picture, which has something of the apparent instability of a Cubist or Italian Futurist painting. But Vlaminck, although influenced by the early Cubism of Picasso and Braque, refused to break with traditional concepts of form and space.

Gwendoline Davies bought *Village Street* from an exhibition at the Mansard Gallery, London, arranged by the Polish-born Parisian dealer, Zborowski.

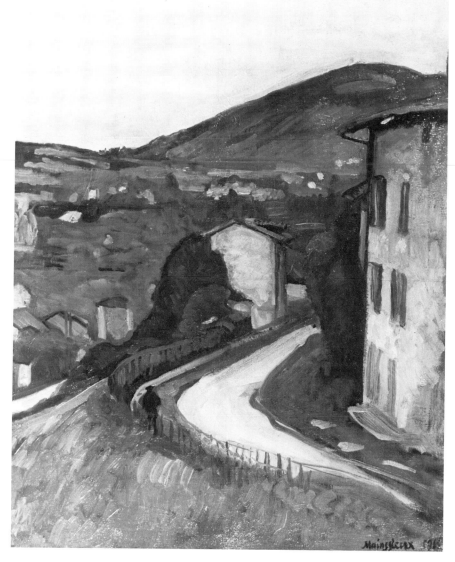

## 83 Village Street

1912, oil on canvas, 31 x 25 ins., 79 x 63.5 cm

Mainssieux was born at Voiron just north of Grenoble and, although he painted later on in Rome and Morocco, this village is probably in the mountainous department of eastern France from which he came.

Margaret Davies bought *Village Street* from the Crane Kalman Gallery, London, in January 1961.

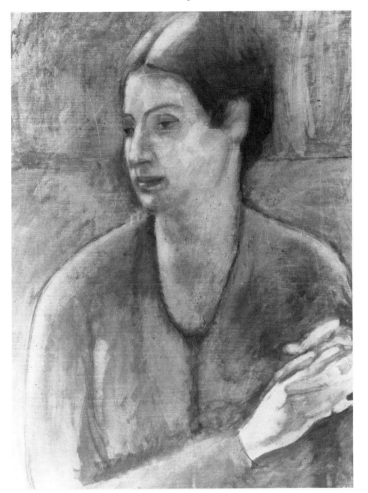

**84 Madame Zborowska**

1919, oil on canvas, 30 x 21 ins., 76.2 x 53.3 cm

The sitter in this portrait was the wife of the Polish-born art dealer, Zborowski (see notes to Nos. 81 and 82). Like Vlaminck, Derain had been one of the Fauves, whose bright colours had caused such an impact at the Salon d'Automne of 1905. By about 1907, however, Derain had abandoned these bright colours in favour of a sombre palette of greens, browns and ochres. In this portrait the only bright colour is the terra cotta shade of Madame Zborowska's blouse. The simplification of this portrait is no doubt due in part to the influence of Negro sculpture; Derain, with Picasso, was one of the first European artists to take an interest in the sculpture of the African continent.

Margaret Davies bought *Madame Zborowska* from the De Lada New Art Salon, London, in March 1920.

## 85 St. Tropez

1918, pencil and watercolour 10¾ x 15½ ins.,
27.3 x 39.4 cm

Signac is best known for his early oil paintings in which, like Seurat, he juxtaposed touches of pure colour according to a technique which he called Neo-Impressionism or Divisionism. This watercolour dates from about thirty years after Neo-Impressionism was at its height. It does, however, retain the use of touches of bright colour, applied here in the form of short strokes, while the actual structure of the drawing is worked out in pencil.

Gwendoline Davies bought *St. Tropez* from the Eldar Gallery, London, in February 1920.

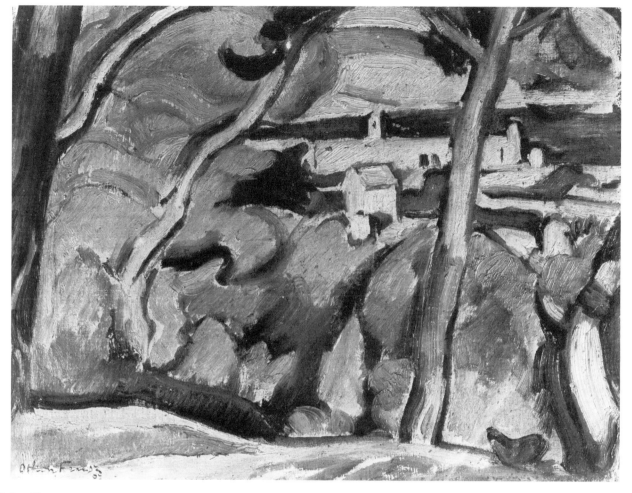

**86 La Ciotat**

1907, oil on canvas, 10¾ x 14 ins., 27.3 x 35.5 cm

The small town of La Ciotat is on the Mediterranean, midway between Marseille and Toulon. Friesz, who was one of the painters nick-named the Fauves (see note on No. 81) worked there with Georges Braque in the summer of 1907. Soon afterwards Friesz began to turn away from Fauvism towards a more classical kind of painting influenced by Cézanne, but this small landscape is still completely Fauve with its strident colours and with the tree trunks which slash emphatically across the canvas. It is the only Fauve painting bought by the Davies sisters and was purchased much later than most of the collection.

Margaret Davies bought *La Ciotat* from the Leicester Galleries, London, in March 1948; it had been in the collection of Hugh Blaker, the sisters' principal picture adviser.

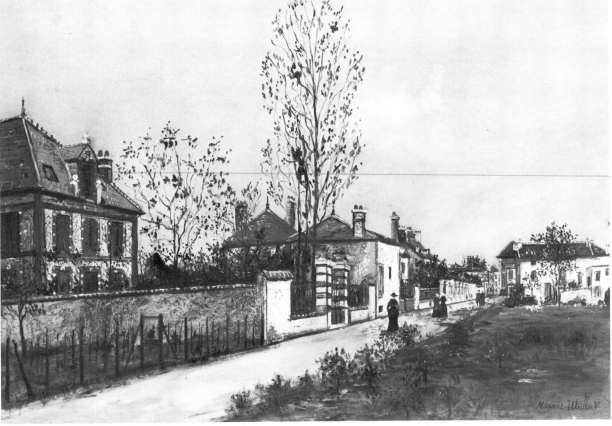

## 87 Village Street
1915, oil on board, 20¼ x 29½ ins., 51.4 x 75 cm

Utrillo, who was the illegitimate son of the painter Suzanne Valadon, was a self-taught artist who began painting after treatment for alcoholism in 1900. He is particularly noted for his paintings of streets in Montmartre.

Margaret Davies bought *Village Street* from the O'Hana Gallery, London, in September 1960.

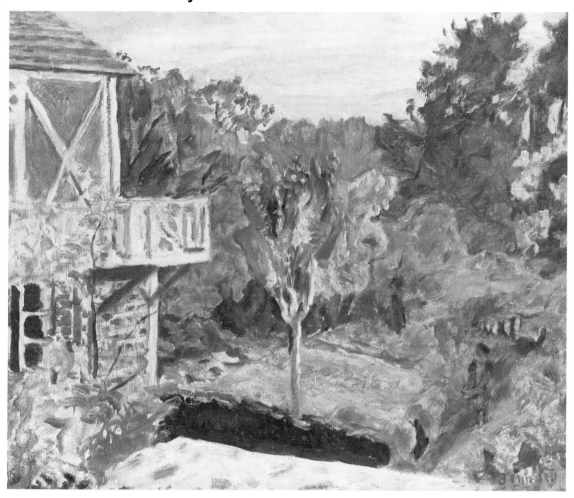

**88 Sunlight at Vernon**

About 1920, oil on canvas, 18½ x 21⅜ ins., 47 x 54.3 cm

Bonnard started painting in a very flat decorative style influenced both by Art Nouveau and by Japanese prints. After 1900 he and his friend Edouard Vuillard turned to painting domestic interiors, often with figures seated on a sofa or round a table; this style of painting was known as *intimisme*. Between the wars Bonnard's colour became brighter, but he retained the domestic emphasis in his pictures, often painting his wife Marthe in the bath. In 1912 he had bought a small house at Vernon, which is a town on the Seine about forty-five miles north-west of Paris. This strongly coloured landscape of Vernon is painted from a high view point, as though from a window of the house.

Margaret Davies bought *Sunlight at Vernon* from Roland, Browse and Delbanco, London, in July 1960.

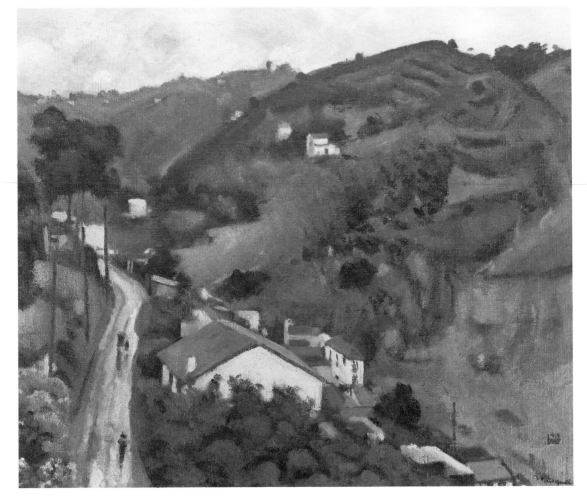

**89 Rain, Mont Plaisant, Algeria**
1944, oil on canvas, 18¼ x 21¾ ins., 46.3 x 55.3 cm

The Bordeaux-born painter Albert Marquet came to Paris in 1890. He became a friend of Henri Matisse and exhibited at the Salon d'Automne of 1905 (see note to No. 81). His prominence in the avant-garde was, however, short-lived and he soon pursued his own speciality which became views of the major ports and harbours of Europe and north Africa, painted very broadly but with great sensitivity to the limpid effects of the maritime climate. This late landscape is untypical in being an inland scene, but in it Marquet has drawn on his experience as a marine painter in giving the effect of a rainy day.

Margaret Davies bought *Rain, Mont Plaisant, Algeria* from the Crane Kalman Gallery, London, in May 1960.

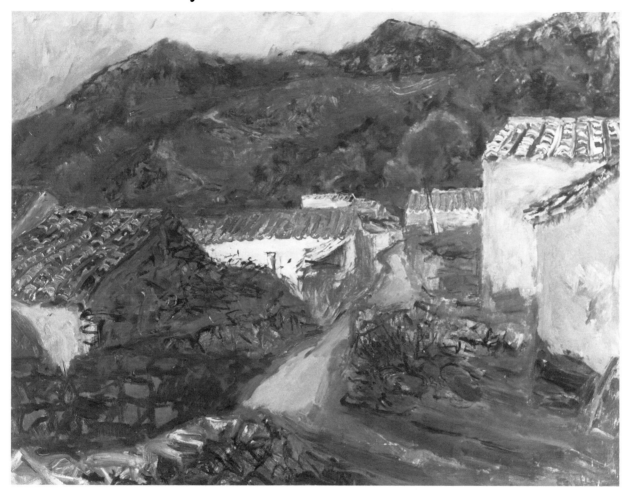

**90 Sardinian Landscape**

Oil on board, 28½ x 36 in., 72.2 x 91.4 cm

Caillard is noted as a widely-travelled landscape painter who embarked, at one stage of his career, on a voyage round the world. As well as landscapes he used to undertake mural decorations before the Second World War, carrying out a series at the Musée Guimet and at the Palais de la Découverte in Paris. The artist has stated that this landscape was painted in 1957.

Margaret Davies bought *Sardinian Landscape* from Wildenstein's, London, in May 1959.

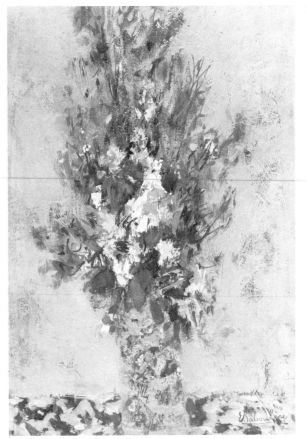

**91 The Blue Vase**

Oil on canvas, 21¾ x 15 ins., 55.2 x 38.1 cm

Baboulène, who was born in Toulon, trained in Paris up to 1931 at the Ecole des Beaux Arts and at the Ecole des Arts Décoratifs, but then returned to his native city on the Mediterranean coast. *The Well*, which shows a village near Toulon, was painted in 1953 and like most of Baboulène's paintings is carried out in pastel-like colours. *The Blue Vase* was painted in 1959.

Margaret Davies bought *The Well* from Arthur Tooth and Son, London, in April 1954. She bought *The Blue Vase* from the same dealers in June 1960.

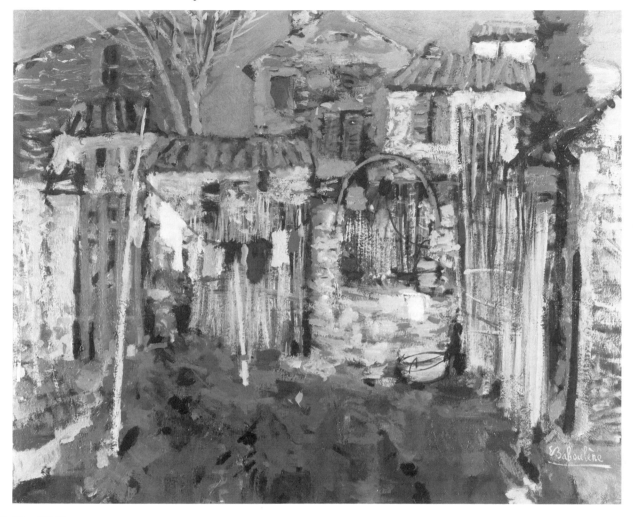

**92  The Well**
  Oil on canvas, 29 x 36¼ ins., 73.7 x 92.1 cm

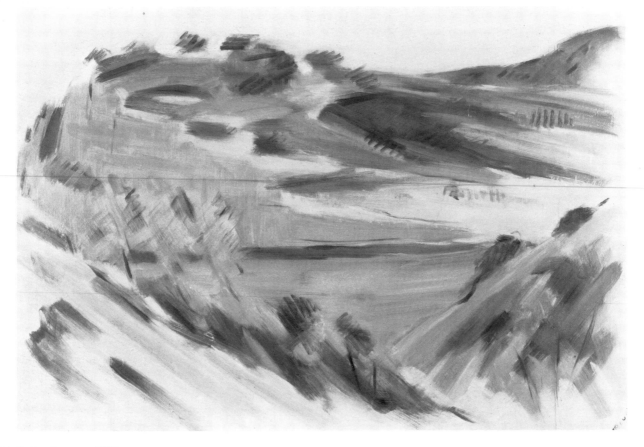

**93 Lake Among Hills**
1953, oil on canvas, 23 x 33 ins., 58.4 x 83.8 cm

The Paris-born painter Yves Rouvre served both in the Second World War and afterwards in Tunisia. Back in France he moved near Aix-en-Provence and then to the country behind Bandol, halfway between Marseilles and Toulon. This landscape is thus from that part of southern France, the department of the Var, which lies inland from Marseilles and Toulon.

Margaret Davies bought *Lake Among Hills* from the Leicester Galleries, London, in January 1955.

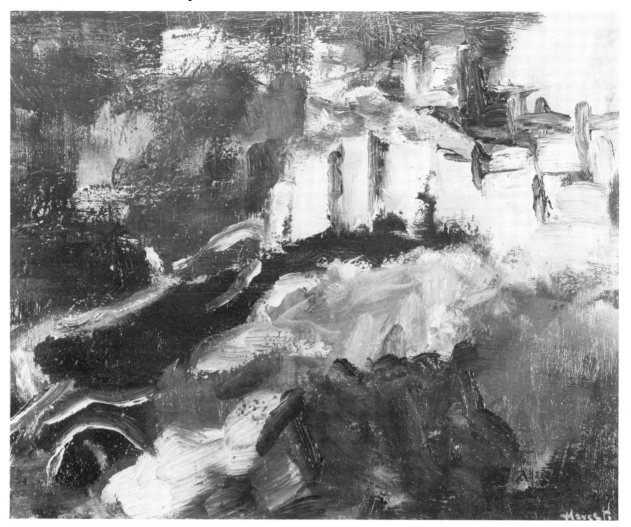

**94 Tourettes de Loup**
Oil on board, 10¾ x 13¼ ins., 27.3 x 33.6 cm

Pierre Havret was born in Brittany, but works in the south of France where this almost abstract landscape was painted.

Margaret Davies bought *Tourettes de Loup* from the Leicester Galleries, London, in February 1956.

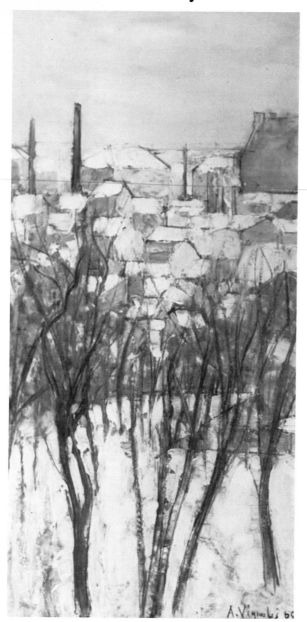

## 95 Snowscape

1960, oil on canvas, 24 x 12 ins., 61 x 30.5 cm

The purchase of this painting in the year it was painted shows how Margaret Davies continued to take an interest in the work of living painters, both French and British, right up to the end of her life.

Margaret Davies bought *Snowscape* from Arthur Tooth and Son, London, in June 1960.